Also by Steven Holtzman

Digital Mantras: The Languages of Abstract and Virtual Worlds

DIGITAL MOSAICS

The Aesthetics

of Cyberspace

Steven Holtzman

Simon & Schuster

SIMON & SCHUSTER
Rockefeller Center
1230 Avenue of the Americas
New York, NY 10020
Copyright © 1997 by Steven Holtzman
All rights reserved,
including the right of reproduction
in whole or in part in any form.

SIMON & SCHUSTER and colophon are registered trademarks
of Simon & Schuster Inc.

Designed by Karolina Harris

Manufactured in the United States of America

10 9 8 7 6 5 4 3 2 1

Library of Congress Cataloging-in-Publication Data
Holtzman, Steven R.
 Digital mosaics : the aesthetics of cyberspace / Steven
Holtzman.
 p. cm.
 Includes bibliographical references and index.
 1. Arts—Data Processing. 2. Technology and the arts.
 3. Computer art. 4. Virtual reality. I. Title.
 NX260.H65 1997
 700—dc21 96-54837
 CIP

ISBN 0-684-83207-0

ACKNOWLEDGMENTS

During the course of writing this book, I've had the good fortune to meet and work with a number of fascinating people. I'm grateful to all of them for their help and support.

To start, I want to acknowledge the many artists and pioneers whose work is the subject of this book. A few shared significant amounts of their time, reviewed the manuscript more than once, and suggested ways of thinking about digital expression that were an inspiration. In particular, I would like to thank J. Michael James; the Perspecta team, including Earl Rennison, Nicolas Saint-Arnaud, and Lisa Strausfeld; and Mark Podlaseck and the team on the *GhostDance* project, including Philip Glass, Robert Israel, and Kurt Munkacsi. Many others contributed as well, including Tim Cole, David Colleen, David Cope, Brian Evans, G. M. Koenig, Bryan Mulvihill, Craig Reynolds, Karl Sims, Alvy Ray Smith, Barry Truax, and Stephen Wolfram. I hope this book conveys their vision and their passion.

The book also would not have been possible without the extensive feedback of Bob Angus, Harry Boadwee, Scott Braddock, Trudy Edelson, and Ann Winblad. In addition, a number of other reviewers generously gave me their comments, including Mike Boich, Philippe Cases, Gary Clayton, Gerry Kearby, Ken Krich, Shantanu Kothavale, Oliver Muirhead, and Mike Siebrass.

Acknowledgments

I thank Bob Bender, my editor at Simon & Schuster. Bob's patient and skillful guidance shaped and then reshaped this book into the form it has today. I'd also like to thank my copy editor, Jolanta Benal, for her meticulous work. Thanks are due as well to my agent, John Brockman, impresario for the digerati.

Finally, my mother, my sisters, and especially Trudy provided me the support and encouragement without which I could not have written this book. Thank you.

CONTENTS

. . . like the baseless fabric of this vision,
The cloud-capp'd towers, the gorgeous palaces,
The solemn temples, the great globe itself,
Yea, all which it inherit, shall dissolve;
And, like this insubstantial pageant faded,
Leave not a rack behind. We are such stuff
As dreams are made of . . .

—WILLIAM SHAKESPEARE, *The Tempest*

INTRODUCTION

I've played the guitar for years, yet I'm still struck with wonder whenever I think about how a mere six strings stretched over a wooden neck have been the source of so much music. The sound of the guitar can't be duplicated by any other instrument. The guitar has made a rich world of musical expression possible.

For example, one of the special qualities of the guitar today is that it can be *electric*. Using the electronic pickups and processing the sound projected through amplified speakers is part of mastering the instrument—whether the result is Eric Clapton's sharp-edged riffs, or Jimi Hendrix's battlefield explosions, or Steve Vai's ear-piercingly harmonized sound, or the fuzzy distortion of grunge. Can you imagine our culture today without the wail of the electric guitar? Probably not.

Like musical instruments, digital "instruments" such as the World Wide Web and the graphics engines that drive virtual worlds represent new vehicles of expression. We're on the verge of a major shift in our culture. Digital technology is everywhere. And like the electric guitar, digital instruments are capable of conveying ideas that can be expressed only in digital form.

As a guitarist, I strive to master the guitar's special qualities. I've always wanted to understand what makes the guitar a vehicle of ex-

pression unlike any other. I assume that, with such an understanding, I can better exploit the guitar's unique qualities. Faced with digital media, I want to learn how to play digital instruments with an impact equal to the wail of the electric guitar. As we master digital instruments, I believe we'll develop a new culture shaped by digital worlds, just as electricity shapes our music today. We'll create a culture born from the invention of digital technology.

Of course, we've all heard about the proliferation of digital technology before. A number of books have addressed the origins and development of digital technology, what it is, and how it works. Others have speculated on how digital technology will transform the way we live as a result of ubiquitous information appliances, wallet PCs, anytime-anywhere communications, data at our fingertips, intelligent agents, and artificially intelligent computers. We can hardly open a newspaper or magazine without finding something about "information superhighways" radically altering how print media, music, television, and movies are delivered. That digital technology is changing the world is already a cliché.

But digital technology will not only change *how* we communicate. It will also change *what* we say, and even how we think. The "content" of human expression will be dramatically transformed as we make the shift to the digital. We are just beginning to understand how what we say and think will be different in the digital worlds of our future.

REPURPOSING

So far we're only in the first stage of encounter with new digital worlds. The special qualities of digital expression remain largely unexplored and unexploited. In fact, they aren't even fully understood yet.

It's hard to imagine with our 20/20 hindsight, but it was years before the first great movie directors, like D. W. Griffith, understood that motion pictures were a new medium very different from photography. The directors of the first movies didn't even realize

that a movie camera could *move*. Like the earlier still camera, the movie camera was anchored in a single location observing the scene before it.

Likewise, we've barely begun to understand the possibilities of digital worlds. Today, we're still approaching new digital media in terms of "old" ways of thinking—even the seemingly most revolutionary new media, such as multimedia CD-ROMs, the World Wide Web, and virtual reality (VR). Most of what we see is built on a foundation rooted in the past. It isn't conceived with digital media in mind and doesn't exploit the special qualities of digital media.

In perspective, this isn't surprising. We're moving through a period in which the new media are approached in terms that give us as familiar a terrain as possible while we develop the concepts and skills that allow us to loosen our conceptual ties to the past. They ease the transition from the old to the new and allow us to make our first explorations of completely new worlds on comfortable ground.

That's why established media distribution giants have rushed to acquire libraries of existing material to deliver in new digital forms. They're approaching new digital media with material that they already know, with concepts and content that they're comfortable with. They're looking for content to *re*deliver—to "repurpose"—in digital forms.

Steven Spielberg, Jeffrey Katzenberg, and David Geffen founded DreamWorks SKG on a vision of mastering new technologies so they can efficiently redeliver material created with one medium in mind (such as movies) on other media (such as multimedia CD-ROMs). Repurposing material is a great way to squeeze every last bit of profit from any creative idea. The same material is used over and over and over again. For example, a movie theme can be repurposed in the form of a toy—Batmobiles or stuffed Lion Kings—and the same creative material can also be used as the basis for an interactive CD-ROM, a Nintendo game, and a screen-saver.

This practice of repurposing existing material is everywhere in digital media today. More than half of today's CD-ROMs consist of

reference material—including dictionaries, encyclopedias, and legal, medical, financial, and educational works—repurposed from other sources. The CD-ROM entertainment world is dominated by repurposed material. A new movie is released on CD-ROM for incremental revenue just like any other item for merchandising. Music CD-ROMs consist of existing music and videos combined with background information and other materials accessed with Dungeons-and-Dragons-like hyperlinks to add adventure. It's old content repurposed on new digital media. Neither the music nor the videos were created with the medium of interactive CD-ROMs in mind.

The same is true of new on-line media. Newspapers are reformatting their print news for access over the Internet. Microsoft established a venture with NBC to repurpose the day's news for on-line access. Large publishers are honing their ability to publish the same material in print, in an on-line consumer vehicle such as America Online, and on the World Wide Web with software that automatically reformats the same content for each destination. Tools for repurposing documents, such as Adobe Systems' sophisticated Acrobat software, "guarantee that every document you [re]publish on-line will look like the original."

Although perhaps it's less obvious, even the way we interact with new digital technology is based on repurposing. Rather than reusing published content, everyday frameworks are repurposed to provide conceptual metaphors for using computers. The computer interface that simulates an office—with a desktop, file folders, trash bins, in and out boxes, telephones, and other icons—makes the computer more comfortable and familiar. It allows us to start to use this new tool by thinking about it in terms of well-understood ways of working. Computer graphics terminology includes paintbrushes, airbrushes, spray cans, color palettes, and other existing tools, permitting artists to quickly grasp the familiar metaphor for a digital tool or process. Similarly, virtual interfaces let you move your hand to open file drawers, pick up file folders to be opened, and leave files organized on an oak desktop. Most virtual-reality experimentation is concerned with simply simulating physical reality.

But in the end, no matter how interesting, enjoyable, comfortable, or well accepted they are, these approaches borrow from existing paradigms. They weren't conceived with digital media in mind, and as a result they don't exploit the special qualities that are unique to digital worlds. Yet it's those unique qualities that will ultimately define entirely new languages of expression. And it's those languages that will tap the potential of digital media as *new* vehicles of expression.

Repurposing is a transitional step that allows us to get a secure footing on unfamiliar terrain. But it isn't where we'll find the entirely new dimensions of digital worlds. We need to transcend the old to discover completely new worlds of expression. Like a road sign, repurposing is a marker indicating that profound change is around the bend.

DIGITAL WORLDS

When I refer to digital worlds, I have in mind worlds unlike any others we have known. Delivered via new digital media such as the World Wide Web and virtual-reality systems, these worlds have no tangible being; they exist only as bits of information. They exist only in "cyberspace."

Cyberspace is an imaginary place located entirely in the digital domain. The science fiction writer William Gibson coined the term in his book *Neuromancer,* published in 1984. It's where whatever you view on your computer screen exists—the text documents you view, the three-dimensional computer-generated graphics worlds you experience, the electronic geography you traverse when you are connected to the World Wide Web. Your computer display is your portal to cyberspace.

Digital worlds are not like the worlds of nature. They're artificial worlds made by humans—and computers. Like human-made art, theater, music, literature, poetry, and sculpture—all worlds of our imagination—digital worlds have the potential to express startling ideas and profound emotions in a way no other medium for human expression can.

Exploiting qualities unique to digital technology, digital worlds cannot exist independently of a computer. *They are worlds that could not even be conceived without digital technology.* These are the worlds that soon will define and fill ethereal cyberspace and that represent an unexplored frontier of human expression.

A TRAVELER'S GUIDE

What will future digital worlds be like? I'm reminded of an anecdote about a jazz musician, Humphrey Lyttelton: When asked in the 1950s where jazz would be in thirty years, he responded, "If I knew, I'd already be there."

When you're looking at a flat two-dimensional "page" on the World Wide Web today, the possibilities aren't obvious. But we are starting to glimpse these entirely new digital worlds. A number of pioneers, like prospectors on the frontier, are searching for them. I've been lucky to have the opportunity to peek at what some of them have found.

Part I of this book, "A Tour of Digital Worlds," describes what I have seen and offers some explanation, to provide a sort of traveler's guide to these new digital worlds. I've found the most interesting previews of digital worlds in the works of pioneering artists and in research at universities and advanced development labs.

Part I is organized into a handful of chapters. "Wired Worlds," "Virtual Worlds," "Software Worlds," and "Animated Worlds" each illustrate what I believe are unique qualities of digital worlds. Given the early stage of our understanding of digital worlds, I don't suggest that this represents the definitive way to classify them. But each chapter should give you a sense of the potential of each quality. At times, reading through these chapters and exploring each quality in isolation, you may feel somewhat like the blind man touching an elephant—you're not sure if you're holding the tail, the trunk, the legs, or something else. The final chapter in Part I, "*GhostDance*," illustrates the possibilities when all these different qualities are employed together. It's a complete view of the ele-

phant—an example of a digital world filled with rich sensory experiences that can only exist in cyberspace.

Like my classification of digital worlds, the list of worlds selected for this brief tour isn't definitive. It's still far too early to identify "masterworks" that will stand the test of time. The selection is somewhat serendipitous; it's based on what I have personally seen and what has captured my imagination. Nonetheless, the examples do show how digital worlds will make new forms of expression possible. They illustrate new ways to navigate through cyberspace, fractal art and virtual sculpture that exploit the unique qualities of virtual space, worlds teeming with artificial life animated by computers, and entirely new forms of interactive musical experiences. If you have experienced any of today's on-line services or surfed the World Wide Web and found it intriguing, just wait—the full potential of digital worlds is still to come!

As we begin to explore digital worlds, Marshall McLuhan's declaration "The medium is the message" still rings true. Part II, which takes its title from McLuhan's remark, takes a step back from the experience of these new digital worlds to examine how the qualities that make them truly new vehicles of expression also shape and define the worlds themselves. The goal is to lay a foundation for understanding and appreciating these digital worlds, to develop a new aesthetic—a "digital aesthetic"—that reflects the essence of digital worlds.

As you read these pages, keep in mind that digital worlds are still in their infancy. As a result, they demand that you actively fill in the details with your imagination, just as you connect together the dots on a television screen to perceive a fully resolved image. However, don't confuse a clear vision with a short distance to get there. It will take a while to realize some of the digital worlds described here. Even the most powerful supercomputers, with tens of thousands of processors executing in parallel, cannot yet render an experience with the richness of the "real" world we experience every day. But when I fill in the gaps left by low resolution and jerky sequences of images, I'm stunned by the possibilities. And I know that more powerful tools are on the way.

THE SUBSTANCE OF CYBERSPACE

I see a future with tremendous potential. Digital instruments will expand the languages of human expression so that we will express things we could not express before. We will discover spectacular worlds unimaginable before the invention of the computer. I believe it's here—in these entirely new worlds—that we will find the *soul* of digital culture. The uniquely digital experience is the substance of cyberspace.

Digital worlds are reshaping how we communicate and express ourselves; ultimately, they will reshape us and even the logic with which we think. In the end, this new thinking is what will make the impact of digital technology so significant. This is how digital technology will transform our culture, how it will shape its content in a way that ultimately reshapes us.

PART I

A TOUR OF
DIGITAL WORLDS

1

W i r e d W o r l d s

I W A S first introduced to the Internet (actually, its predecessor, ARPANET) in the seventies. In the dimly lit basement of the computer science department at Edinburgh University, words formed by dots of green phosphor scrolled from the bottom to the top of my computer screen—a computer terminal attached to a DEC minicomputer that in turn was my gateway to the Internet. E-mail messages connected me with others, mostly in the United States and elsewhere in the United Kingdom. Sometimes, the fluorescent words documented exchanges among groups of people in "chat" sessions.

At the time, the Internet was the exclusive domain of the technically savvy, accessible only to hackers capable of mastering arcane commands and complex communications technology. A particularly elite group spent hours on end in role-playing adventure games similar to Dungeons and Dragons. Communicating via the Internet, they conjured up imaginary worlds using only words and their imaginations. Appropriately, they played the roles of wizards skilled in magic and sorcery as they wandered through enchanted kingdoms and the dark chambers of ancient castles.

Now, point-and-click interfaces to the World Wide Web have made the Internet's vast global tapestry of resources available to anybody who can use Windows or a Macintosh. Viewing a typical

Web page today, we click on words underlined with a thin blue line, jump through cyberspace, and arrive at a destination that can be on the other end of the earth. These "hyperlinks" can point to somewhere on the same computer we're connected to, or to any other computer connected to the Internet anywhere in the world. Hopping around the globe, tens of millions of us connect to the Web, travel to virtual meeting places, enter chat rooms, and share ideas with others who can be almost anywhere.

The Web is a new type of digital world that's on-line. The Web is wired. A dense mesh of links spans the planet to form an organic whole, a shared network of virtual connections open for exploration. The Web is an entirely new medium, a medium in which you must actively participate. You have to direct your travels *through* cyberspace—the Greek word *kybernan,* after all, means "to steer." Whether you're a hacker or you're taking a casual stroll through the links of the World Wide Web, you're navigating your way through virtual cities of bits, the world of 1s and 0s.

RIDING THE DATAWAVE

I sometimes imagine myself as a hacker at the digital frontier, like a gunslinger in a John Ford Western:

Hopping from site to site through sixteen "hosts" I arrive at the mainframe of a Los Angeles aerospace company. Surfing in under the watch of the system operator (a "sysop") I browse the directory of databases. I get an electric thrill from diving to penetrate the data constructs of a supposedly secure and encrypted file.

Then something triggers the sysop. He's suddenly active. No need to take any chances. I get back on my virtual board and disappear deep into a group of conversations crossing the network. Buried in the barrage of data, I hitch a ride hidden in the tail of a passing data stream. My trail of digital dust forms a small packet storm.

I'm off to another system. I pass through a series of hosts on the tips of white-crested datawaves and arrive at the financial archives of an international bank. . . .

A hacker sees the world of bits as a place for adventure. Hackers thrive on the thrill of cracking a well-protected system.

In this untamed territory, people connected to the Internet construct "firewalls" to block hackers' entry into areas where they are not welcome. The firewalls are protective barriers, like the walls of ancient cities. There is only a single narrow gate; traffic can exit but can't easily get in.

To expand the metaphor, cyberspace itself can be modeled on the architecture of our familiar real-world landscapes. William Mitchell is the dean of the School of Architecture and Planning at the Massachusetts Institute of Technology. In his book *City of Bits*, he suggests that the structures of cyberspace can be thought of in terms of the structures of architecture.

> The network is the urban site before us, an invitation to design and construct the City of Bits. . . . This will be a city unrooted to any definite spot on the surface of the earth. . . . Its places will be constructed virtually by software instead of physically from stones and timbers, and they will be connected by logical linkages rather than by doors, passageways, and streets.

In the physical world, we design buildings to suit how we live; particular places for various activities are connected by a circulation system. Doors and passageways integrate various parts into a functioning whole. In a house, for example, we set aside a room for sleeping, a room for eating, a room for entertainment, perhaps another for exercising. In a school, we designate classrooms for teaching, libraries for studying, gyms and playing fields for physical education, and auditoriums for special events.

We structure a number of buildings in turn to create whole cities, just as Baron Haussmann designed a radial pattern for Paris and Daniel Hudson Burnham created a grand plan for Chicago. The architecture of buildings and even cities guides us through their space.

Although we will eventually design interfaces that go beyond today's familiar navigation cues, the metaphors of architecture from our real world can provide a familiar landscape for navigating

wired digital worlds. We can build the structures of cyberspace using a floor plan from a traditional store, library, theater, school, bank, stock exchange, office, house, or any other kind of building. We can even build a complete virtual city. To see how, I visited David Colleen of San Francisco's Planet9.

VIRTUAL SAN FRANCISCO

One of San Francisco's leading architects, Colleen designs "spaces," including office buildings, retail stores, restaurants, and housing complexes. His design studio is located in San Francisco's Hills Plaza complex, a stunning waterfront property featuring offices with breathtaking views, some of the city's hottest dining spots, and a few floors of residential space above it all. It was in 1988, while working on Hills Plaza, that Colleen used a computer as part of his design process for the first time: he created the tile patterns in the Hills Plaza restrooms pixel by pixel with a PC-paint program.

Over the next few years, he began to use much more sophisticated digital tools to preview his projects in the virtual world before he built them in the real world. He created models of the buildings that he and his clients could "walk through" to see if they met their objectives.

Clients as well as city agencies that approve projects soon asked to see what a proposed building would look like in the context of its surrounding environment. As a result, in order to place his designs in context, Colleen began to develop a library of the existing buildings in San Francisco. Now he's building a complete virtual San Francisco. Colleen explained to me, "The goal isn't so much to build a model of San Francisco; rather it's to develop a new interface to navigate through cyberspace." Colleen instructed the computer to start up the virtual San Francisco world, gave me a quick overview of the navigation controls, and then let me take over.

I have a bird's-eye view as I approach San Francisco from the west, flying over the Golden Gate Bridge, and come in over the bay. I see

the white column of Coit Tower perched on top of Telegraph Hill and, beyond it, the cluster of buildings that is San Francisco's downtown.

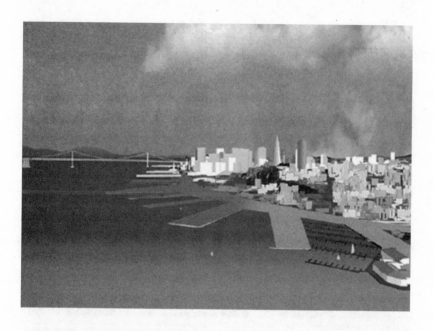

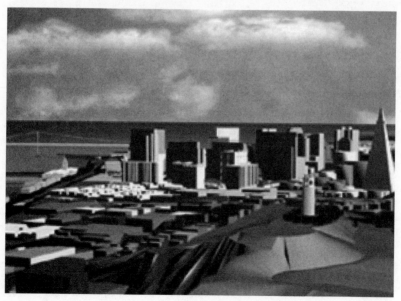

I fly in low, head down Battery Street, and then cut across Montgomery. I love the sensation as the skyscrapers swoosh by, towering above me on both sides—the TransAmerica building on my left, the Charles Schwab building farther down on my right.

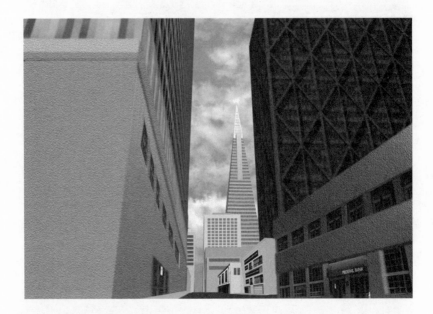

As I cross Market Street I regain height so I can easily spot South Park, a landmark in the middle of the refurbished lofts, warehouses, and industrial buildings that have been given facelifts and transformed into San Francisco's Multimedia Gulch. I land in the park.

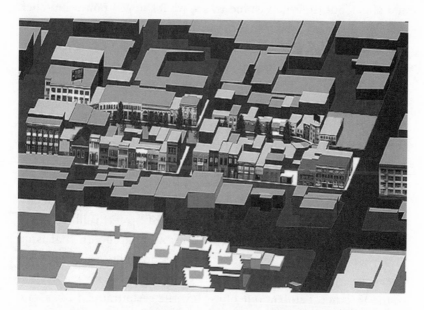

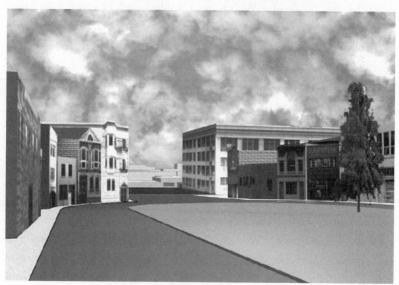

The buildings appear remarkably realistic; they are photos of the building facades pasted on the abstract virtual structures. A car drives by. I look toward Third Street and see the tattered white ex-factory that is now home to Wired Ventures, publisher of both *Wired* magazine and the Web publication *HotWired*. I stop briefly and check out their newsstand to see what's new. I point-and-click to bring up a listing of the contents of *HotWired*'s latest edition. A teaser-animation greets me with the banner "I Love Frisco"—a rather appropriate theme for my tour—and suggests a visit to the "Cocktail" section of this on-line magazine. I'm then presented with *HotWired*'s navigation and contents page. Given Cocktail's theme, the "Frisco," I do decide to take a closer look. The recipe for this drink includes bourbon, Benedictine, and lemon juice. As I read about how popular it was after California's gold rush in the 1850s despite the objections of the Ladies Outdoor Art League of San Francisco, I'm reminded of the frontier roots of this virtual city.

I continue on my way and cross Howard Street. Billboards advertise various merchants' wares. I pass a phone booth that is an "Internet phone"—a telephone connection that provides long-distance service at no extra charge beyond the cost of my connection to the Internet. I stop at one of my favorite restaurants, Lulu's, and scan the menu on their Web page. It looks good, as always, so I pop up a reservation form and book dinner for 8:15 P.M.

I then go to the building where the software company Macromedia has its offices. I pass through the virtual doors with a mouse click and select "Product Information" to check on features in the upcoming release of *Shockwave*, software for delivering multimedia content on the Web. After this brief detour, I head over to the Museum of Modern Art across from the Moscone Convention Center. Even in the virtual world, the museum lobby is stunning—the marble floors, the funnel ceiling with its brilliant skylight, the skywalkway on the fourth floor. Today there's an exhibition of young San Francisco artists who create their work using digital tools.

Virtual San Francisco is an interactive community directory and travel guide. You can walk or fly down streets, enter buildings, and check out a company's home page—to shop, review restaurant

Tuesday
24 Sept 96

NETIZEN
pop
HOTBOT
[ask] Dr. Weil]
WIRED
SURF CENTRAL
Rough Guide
Cocktail
webmonkey
Dream Jobs
PACKET
TALK GUIDE

IN COCKTAIL
The Frisco is made with bourbon, benedictine, and lemon juice, and has far more taste than its name.

DREAM JOB IN THE BERKSHIRES
This Web zine targets the "transition" generation - and seeks someone to "transition" to a new job.

YES TO OXYGEN, NO TO H_2O_2
What's good for your wounds isn't so good for your guts. Dr. Weil says: Don't imbibe.

NAVIGATIONAL ERRORS
Webmonkey depicts great failures in plug-in history.

EXQUISITE CORPSE
Former dancer, candymonger, and mousekeeper Poppy Z. Brite talks horror fiction, live in Club Wired.

BACK TO CULTURE-BASHING
Dole's imploding campaign makes Katz long for Gingrich's heyday and bewail Clinton's free ride.

Cocktail
On the men

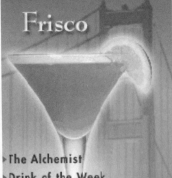

Frisco

▸The Alchemist
▸Drink of the Week
▸Suggested Servings
▸The Virtual Blender
▸The Recipe

Frisco

Rarely do we call this d:
order it whenever we ha
not for its bite. The abb:
grace has caused this ve
disappear. Benedictine,
softens the Frisco's rye
taste.

Sophisticates, we're tol-
California's gold rush i:
as many Easterners poir
certainly uncouth, and p
pony of rye with a dash
it's tough to imagine so:
with the foresight to tra
European liqueur out W
the Old School of Amer:
in 1897, we're not that :

menus and make reservations, see the latest editions of the publications headquartered here, and get updates on the entrepreneurial multimedia companies that make San Francisco a center for innovative digital content.

THE GLOBAL VILLAGE

On-line cities aren't just filled with buildings and other static spaces. These cities are developing around the millions of people who are already forming virtual communities in cyberspace, communities unrestricted by physical location or distance. The success of on-line services and their "chat rooms" suggests that many people are more interested in communicating with others than in browsing through masses of electronically accessible information.

This vast network of personal communication fulfills the vision of Marshall McLuhan. McLuhan is perhaps most often cited for his prediction of a "global village" created by electronic technology:

> Electric speeds create centers everywhere. Margins cease to exist on this planet. . . . Our specialist and fragmented civilization of center-margin structure is suddenly experiencing an instantaneous reassembling of all its mechanized bits into an organic whole. This is the new world of the global village.

McLuhan forecast a world in which the possibility of instantaneous electronic connections between any two (or more) points in the world virtually removes the barriers of distance that separate people. In that world, even people in the most remote locations are connected to others; the very notions of "center" and "periphery" must be redefined.

The World Wide Web is the foundation of McLuhan's global village. As a large-scale structure of virtual places in cyberspace, the Web is organized to meet the needs of its inhabitants just as places are in the real world. The Web is a window into a social space.

The Web is a catalyst for human communication, bringing together people from across the planet. People interacting with other people anywhere on the global network in chat sessions at virtual

cafés and group gathering places known as MUDs (multiple-user dungeons) and MOOs (object-oriented MUDs). People from different cultures share their ideas in the ethereal world of cyberspace. People do the things they might do in the real world, but they are unconstrained by time and place. Howard Rheingold writes, in the introduction to his book *The Virtual Community*:

> People in virtual communities . . . exchange pleasantries and argue, engage in intellectual discourse, conduct commerce, exchange knowledge, share emotional support, make plans, brainstorm, gossip, feud, fall in love, find friends and lose them, play games, flirt, create a little high art and a lot of idle talk. People in virtual communities do just about everything people do in real life, but we leave our bodies behind.

These are communities not of common location, but of common interest, webs of human relationships linked in cyberspace.

THE VIRTUAL CAFÉ

One of the first graphical virtual communities was the world of Habitat, developed by LucasFilm Games. Habitat is a pay-per-minute virtual game; players log in via a modem, meet other players, engage in treasure hunts, publish newspapers, and get married and divorced. Habitat adopted the term "avatar" to refer to players' cartoonlike personas, which interact in this virtual world. Avatars communicate like the characters in a comic strip, via speech balloons that appear above their heads. Launched in 1989 by QuantumLink Communications, Habitat never really caught on in the United States; it attracted only 15,000 inhabitants after a couple of years in operation, too few to support a viable commercial enterprise. (An adaptation by Fujitsu in Japan met with greater success.) In 1993, however, QuantumLink "reinvented" itself as America Online—today's largest on-line service provider, with over 7.5 million subscribers worldwide. The popularity of chat rooms exploded along with the number of America Online's subscribers, and they remain a prime attraction today.

In fact, chat rooms are popping up all over the Internet. Traveling across the Internet today, I can temporarily join any number of communities dedicated to a vast number of subjects. I head over to one of my favorite gathering places, a site of philosophical discourse. The general theme posted for today: "What will happen when, in just a few years, the population of McLuhan's global village is over 100 million, larger than most countries?" This sounds like it's worth a visit.

I look at who's logged in at the moment. Five others are listed.

1 Starseed
2 Gutenberg
3 Lestat
4 Hive-Mind
5 Toronto

I join the group, identifying myself as "Zen," and try to get a sense of the discussion.

LESTAT: Soon commercial interests will take over the Net. Then, like TV, the most advanced product of the technological genius of an entire species will again convey Geraldo Rivera to millions of homes in breathtaking color.

HIVE-MIND: No. What's beautiful about the Net is that there can be no controlling interest. The Net has no center. It's a bunch of dots connected to other dots, a cobweb of arrows pouring into each other, squirming together like a nest of snakes.

GUTENBERG: But what does this make us? A society of isolated individuals?

TORONTO: Rapid technological change scrubs off our identities and electric technology removes us from our bodies. We then become "nobodies." When we attempt to retrieve that which was lost, the "nobody" emerges very insecure and the outrage is expressed physically, intellectually, and socially. Electric technology turns us all into the lone cowboy on the range, having lost all relationship and all signposts.

I think to myself how so much of what's on the Web today is self-referential. (Speculation about the Web's future supports a whole industry.) I also note how, as always seems to be the case on the Internet, the conversation is only loosely moderated. Different people represent a broad range of views. The interchange is not as disciplined as it might be if everyone were face to face—but then this exchange probably would never happen in a face-to-face meeting. In a virtual exchange, you can be anywhere. More important, this is a motley group who otherwise might never get together. The Internet enables new forms of community not only free of time and location, but also of traditional social barriers. Their identities never quite clear, here they anonymously exchange ideas.

GUTENBERG: We are less and less what we were. As we are pulled into the Web the idea and role of individuality comes under siege.

LESTAT: Individuality? We have no static identity. In the context of virtual systems, it's obvious that multiple selves can

inhabit a single body. Who are you out there? Are you the same person when you log off? Male? Female? Has your idea of yourself changed over time?

Each speaker has the option to offer a brief description of himself. Wondering who's behind the voice of Lestat, who discusses the issue of identity with such conviction, I bring up a pop-up window on my display (see box). A transsexual and a university professor—here's someone who has dedicated his/her life to understanding shifting identities. Who is this Lestat, really?

Issues of identity are the stuff of Internet folklore. In cyberspace, your identity is usually a projection in words and images. You can consciously construct it to be something very different from your everyday persona. You can easily pretend to be someone else and try on different identities and attitudes. And so can everyone else. As a result, you can never be quite sure whom you're really talking to.

> Vampire Lestat: assistant professor and director of the Interactive Multimedia Laboratory at the University of Texas. Transsexual. I choose the identity of Lestat who, as a vampire, struggles with the swiftly changing meanings of what it is to be human, or for that matter, unhuman.

The first time this was brought home to the on-line community was back in 1982, when Sanford Lewin, a male psychologist, assumed the on-line identity of Julie Graham in a CompuServe chat group. Lewin presented Julie as a New York neuropsychologist who had been involved in a serious car crash caused by a drunk driver. Her boyfriend was killed and she suffered severe neurological damage: she was now mute, disfigured, and paraplegic. The on-line world was Julie's only link to the outside. This tragic figure attracted the sympathy of a collection of women with whom she rapidly achieved intimacy. They shared their secrets and sought Julie's professional advice.

Finally, as her story grew more and more implausible, Julie tripped up. When Lewin's deception finally began to unravel in 1985 and it became clear that he was neither female, mute, disfig-

ured, nor disabled, the anger and emotion of the deceived women sent ripples across the whole on-line community. They accused Lewin of "rape." A news report quoted one of the deceived as saying, "We lost our innocence, if not our faith." Today it's better understood that role-playing and even assuming false identities are part of the on-line world. It's part of the medium.

Meanwhile, the discussion continues.

HIVE-MIND: But when we wire ourselves up into a hivish network, many things will emerge that we, as mere neurons in the network, don't expect, don't understand, can't control, or don't even perceive.

STARSEED: Yes. As more and more individual human cells become tuned in to what is taking place, a new awareness will increasingly filter into human consciousness. The change will accelerate exponentially. Eventually, the psychic pressure exerted by a critical mass of humanity will reach levels that are sufficient to tip the scales. At that moment, the rest of humanity will experience an instantaneous transformation of a proportion we can't now conceive. :)

ZEN: The individual who lets go of his isolation is absorbed into the network that spans the globe. Every expression is a node in the web.

HIVE-MIND: The Net is the archetype representing all circuits, all intelligence, all interdependence, all things economic and social and ecological, all communications, all democracy, all groups, all large systems.

Discussions like these epitomize the Internet and reflect the sixties-ish San Francisco counterculture and idealism that have become its ideological foundation. A center for multimedia and, in particular, the World Wide Web, the San Francisco Bay Area is home to the voices of the digerati, from Stewart Brand's *Whole Earth Catalog* to Berkeley's cyberdelic *Mondo 2000* to *Wired* and *HotWired*. Countercultural themes—such as a distaste for centralized control or any form of censorship—are the norm. At the same time, San Francisco's high-technology priesthood have reconciled

the transcendentalist idealism of the sixties psychedelic subculture with the technology of the nineties to create the foundation for a new cyberculture.

VIRTUAL GAMES

As I exit the chat session, my thoughts are buzzing from the stimulation. I think about visiting somewhere with lighter fare—maybe the America Online chat room known as Ferndale. Ferndale is an "interactive soap," in which every participant has a role in an evolving story. Then again, maybe I'd rather go for an on-line interactive game—*Quake*? Too gory. Instead, I take an observation post at a virtual tank range.

The Internet originated in research funded by the U.S. Department of Defense. It was the DOD's Advanced Research Projects Agency (ARPA) that first provided funding to facilitate communication and the sharing of resources among its research projects throughout the United States. (The DOD network wasn't in fact built to protect national security in the face of a nuclear attack—a commonly accepted myth.) The first demonstration of ARPANET, a prototype of today's Internet, occurred in 1969 at the University of California at Los Angeles. It wasn't until 1983 that ARPANET was divided into separate military and civilian networks—MILNET and ARPA Internet—and the basis for today's anarchic global network of networks, known simply as the Internet, was formed. The military network continues to live a separate life, supporting a cyberculture of a decidedly different nature than the more accessible one grounded in sixties counterculture and idealism.

Putting U.S. tax dollars to work, our military practices for warfare in cyberspace at a virtual tank range. Dozens of trainees, each sitting in the body of a tank simulator, are connected by a network that transmits their movements, actions, and status, accompanying them with the din of radio communications, the roar of tank engines, and the explosion of gunfire.

A tank rolls across the desert terrain and fires. There's an explosion in the distance: a direct hit on an enemy tank. Score one for

the good guys. A burst of radio transmissions conveys the edgy nerves of those in an advance tank. "They've come out of nowhere." A crackling voice requests air cover: a battalion of enemy tanks, until now hidden from view within a shallow crater, is approaching fast.

The terrain is based on very precise maps. I'm reminded of the 1995 peace talks for the Bosnian war held in Dayton, Ohio. A sticking point in the negotiations was a proposed corridor between Sarajevo and the Muslim-held enclave of Gorazde through Bosnian Serb territory. Serbian president Slobodan Milosevic demanded the route be only two miles wide, while Bosnian and American negotiators contended that a corridor five miles wide was necessary. It was only after the U.S. negotiators took Milosevic on a virtual tour of the terrain that he agreed to the five-mile corridor. Constructed using satellite imagery and terrain elevation data, the virtual-reality simulation of the geography—from mountains to streams to roadways, including objects as small as two yards—convinced Milosevic that the mountains made a narrow corridor impractical.

At the same time, I can't help but shiver at the prospect that, in the future, these tanks will be in a real battle, operated remotely—a technology known as telepresence. Instead of watching clips on the television news, we'll watch virtual warfare in cyberspace turn into real warfare with *real* lives at stake—if not soldiers' lives, then those of civilians. Like any new technology, the digital world can be used for peaceful purposes or hostile ones.

A SENSE OF IDENTITY

The global mesh of connectivity forms the infrastructure for building cyberspace. Yet even if virtual worlds are modeled on cities like San Francisco, cyberspace is not built on the same solid foundation as traditional architecture. Rather, cyberspace is constructed from an ethereal substance that is dramatically more pliable than architecture's steel and concrete. As we construct cyberspace, we are developing an architecture that can only exist in the digital realm. But it's still not clear what shape it will ultimately take.

The countercultural spirit of San Francisco forecasts a wired world in which humans are the brain cells while the wires of the Internet act like the axons of nerve cells. Everyone will be connected to form a global village. One day, in an instant, this networked village will attain critical mass and create a new global consciousness. The Internet's foundation was built on military research, but today the countercultural spirit of the Internet is more threatened by the commercial interests of big business than by the military.

The millions of people who connect to the Internet, particularly the World Wide Web, are generally highly educated and high income. These demographics have caught the attention of businesses looking to advertise and sell their wares. After twenty-five years of relative obscurity for the Internet, businesses, advertisers, and high-tech entrepreneurs have suddenly realized that it's a new medium—a mass medium filled with lucrative opportunities. These interests imagine the Internet's potential for electronic commerce and are creating designs for virtual shopping malls, developing new forms of "cybercash," and putting in place technologies that will facilitate secure business transactions.

Even if the identity of the Internet is in flux, it's clear that a new kind of wired world is emerging. While the doors and passageways in buildings connect rooms that are physically next to one another, and streets connect buildings and other physical structures, the links in cyberspace connect you to digital worlds anywhere in the world. You move from place to place—from a virtual city to a chat room to an observation post for virtual warfare—independent of their physical location.

And it's not only cyberspace that has a discontinuous shape. As you travel from one digital world on the Web to the next, *your* identity also becomes discontinuous. One moment, you're a pilot flying through San Francisco; next, you're a philosopher contemplating heady intellectual discourse; then, with the click of a mouse, you're a bystander in the middle of a war. The Web will redraw the boundary between our fictitious and our real identities. In cyberspace, that dividing line is permeable. Our identities emerge from fragments connected in a network that forms a complex whole.

Virtual Worlds

. . . I think of unbounded worlds of intense kaleidoscopic images flashing by in rapid succession, fabulous colors, unnatural shapes, and rich textures complemented by unearthly sounds . . . perfect fractal forms . . . abstract three-dimensional mandalas existing only in the ethereal realm of cyberspace. I imagine the possibilities of a world free of physical constraints and made from the infinitely malleable material of the virtual. . . .

Then my thoughts return to the static two-dimensional image on my computer monitor. I could be viewing one of today's multimedia CD-ROMs or a page anywhere on the World Wide Web. More often than not, the pages are still flat. But cyberspace isn't.

"Page" is a metaphor from another medium. Other metaphors, from buttons designed to look like the controls of a stereo or VCR, to shopping malls and urban landscapes, also impose a familiar form on the new worlds of cyberspace.

I look at the words and phrases on my screen underlined in blue. I sense that this convention for hyperlinks is probably already as intractable a feature as the trash cans and file folders of the Apple Macintosh; I imagine we'll live with the legacy of the thin blue line for many years to come. Yet I know that, someday, navigating

through digital worlds won't be like flipping through the pages of a newspaper. New possibilities open with virtual space.

VIRTUOPOLIS

For the most part virtual worlds today are completely grounded in our known and familiar world. Since William Gibson's landmark book *Neuromancer* in 1984, virtual worlds have provided nourishment to science fiction. Ironically, from Gibson to the Virtuopolis of Alexander Besher's 1994 *RIM*, these imagined worlds are fashioned after our known world.

> Satori City, better known as "Virtuopolis," or "Virtualopolis," was developed in the year 2017 by the Satori Group as the world's first online VR city. In terms of its actual tsubo-acreage in Cyberspace, it is equivalent in physical size to the island of Manhattan. Virtuopolis offers fully-equipped virtual reality office buildings—VR-rises—with discrete cells for short- or long-term lease. . . . Dreamtime, one of Satori City's most popular sectors, includes a holographic construct of the Angkor Wat in Cambodia, the ancient temple of Knossos on the island of Crete, a neural version of the Olmec temple complete at Teotihuacan, as well as its famous replica of the Forbidden City in Beijing. . . . On the cultural side, Virtuopolis houses most of the world's leading museums—from the sweeping collections of New York's Metropolitan Museum to the Louvre in Paris, Taipei's National Museum, the Hermitage in St. Petersburg, Amsterdam's Rijksmuseum, the Uffizi in Florence, the Tate Gallery in London, not to mention the important smaller venues like the Picasso Museum in the Marais section of Paris and the Groeninge Collection of Flemish art in Bruges.

The highlights of Besher's imagined virtual worlds of the future are a near-endless catalog of sight-seeing destinations from the real world. Interestingly, Corbis Corporation, founded in 1989 by Microsoft's chairman, Bill Gates, has acquired the digital rights to a broad selection of art, including the collections of most of the museums in Satori City. Corbis already exhibits many of these works in a virtual gallery on the World Wide Web.

In Neal Stephenson's science fiction novel *Snow Crash,* people

exist in the virtual world of the future—the Metaverse—as avatars, "audiovisual bodies that people use to communicate with each other." In a climactic chase in the Metaverse, the hero, Hiro, pursues his adversary, Raven:

> They slalom down the monorail track at speeds from sixty to sixty thousand miles per hour; all around them low-slung commercial developments and high-tech labs and amusement parks sprawl off into the darkness. Downtown is before them, as high and bright as the aurora borealis rising from the black water of the Bering Sea. . . . [Raven] twists his throttle just as Hiro is pulling behind him on the Street, doing the same. Within a couple of seconds, they're both headed for Downtown at something like fifty thousand miles an hour. Hiro's half a mile behind Raven but can see him clearly: the streetlights have merged into a smooth twin streak of yellow, and Raven blazes in the middle, a storm of cheap color and big pixels.

Reading *Snow Crash* kept me at the edge of my seat. But like Besher's virtual world, Stephenson's Metaverse is completely tied to metaphors from the real world—except that there's no speed limit! Avatars have human form and ride motorcycles through a Los Angeles–style metropolis.

THE VIRTUALLY REAL

There are many examples of science fiction that explore the edges of today's techno-fantasy. Yet even this fantasy realm still remains largely grounded in the framework of simulating our known reality. It should come as no surprise, then, that real-world work in computer graphics and virtual reality is also entrenched there.

In fact, the holy grail of computer graphics is to create "photo-realistic" images—computer-generated images indistinguishable from photographic images of the real world. In virtual worlds, the aim is to create an *experience* that seems completely real. Flight simulators, one of the first and most heavily supported areas of VR research, are an example. Beginning with the development of the first flight simulators during World War II, the goal of these sys-

tems has been to create a completely realistic experience of flying so pilots can learn to fly before they ever leave the ground.

A cockpit, with a replica of all of the airplane's controls and windows to the outside world, is mounted on a platform that moves to simulate the motion of an airplane. Images—from the runway to landscapes and the open skies—are visible through the cockpit's windows. The earliest systems projected the images with film cameras. Today, the images generated by powerful computers are much more realistic.

I get into the cockpit of a fighter jet. The canopy closes as electronic control panels flash information about the status of my plane on my heads-up display. Radar. Targeting systems. Weapons systems. I push the throttle forward to take off from the lower deck of an aircraft carrier, pulling on a pressure-sensitive hand control for lift. I'm flying low over water. I see a bridge and a landscape in front of me, come in underneath the bridge, and bank right to follow the river upstream. It flows deep in a canyon whose walls are a blur of reds and browns. The turbulent air jostles me up and down—the computer-controlled movements of the flight pod—as the rock face swooshes by. The instruments indicate that I'm at Mach 2. I'm immersed in another world—experiencing a place, not viewing a picture. I feel that I'm in it—that it's real. I'm completely absorbed.

"Location-based" entertainment makes for a pretty wild ride! These simulators create the sense of total immersion and instantaneous interactivity. They make your heartbeat accelerate; you break into a sweat. You touch a control and there is an immediate response. Such simulators raise questions about what it means to have a "real" experience.

Designers of all kinds are using today's state-of-the-art tools to preview their designs of cars, furniture, tools, household devices, and product packaging as if these were real. Architects do walkthroughs of their building designs to understand how well they will function when they're built. The goal of simulations of our atmosphere, planetary systems, the formation of planetary rings, and the

evolution of solar systems is to accurately portray the real workings of these complex systems.

Science and industry are shifting from observation of the real world to observation of simulations as virtual worlds. But the priority is still to recreate the real, to mimic our known (and unknown) reality. Almost all work in VR today strives to create a perfect simulation of physical reality.

The commercial benefits are enormous. Design time and, as a result, time to market are shortened dramatically. Crash tests on new cars can be performed in the virtual world; new buildings can be studied before they are built; pilots can be trained without endangering themselves or the aircraft. Even the chaotic behavior of the weather and complex economic systems can be more accurately predicted.

Similarly, Planet9's Virtual San Francisco mimics the city of San Francisco in the virtual world of the Web. Other "city" sites are under construction all over the Web. For example, a visit to Worlds, Inc.'s, AlphaWorld on the Web reminds you of Stephenson's *Snow Crash*. You're invited to "acquire and develop property, assume an online persona, and interact in and with a living, breathing, multiuser community." These virtual cities are like cities we know; as a result, it's easy to find your way around. Street grids and office towers provide you with a sense of the familiar, as if you were a tourist arriving at a foreign destination.

But, while the point of these projects is to develop the virtually real, virtual worlds need not be confined to simulations of the real world. For example, IBM's Electronic Commerce Services group is designing "a new architecture for an On-line City of Digital Commerce." The goal is to create a cybermall for shopping on the World Wide Web that doesn't look or feel like a real-world mall. In this virtual world, geometric structures float suspended in space. Various retailers set up stores that are represented by spinning spheres. Like satellites in orbit, the structures rotate at varying speeds.

Merchants' logos and advertising invite me in to browse through

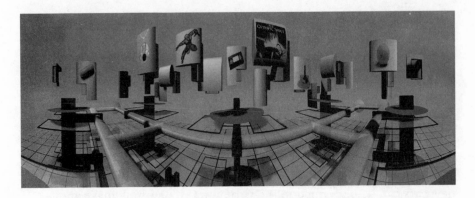

products or to check out various services for travel and banking. As I navigate with a mouse, a shiny orb glides through the space; it's me, my avatar. I'm not represented by a human form—I'm an abstract avatar that sparkles in the virtual light. I decide that maybe I should punish my credit card, so I head into one of the music stores in search of something to download. After auditioning a handful of songs, I select the ones I like, pay about a dollar per track, choose an order in which they'll play, and burn a customized CD to take on my drive to L.A. over the weekend.

What's most interesting about the potential of virtual worlds isn't how well they can imitate physical reality. Rather, it's the entirely new worlds that could not have been imagined without the computer. There are alternatives to designing virtual worlds to simulate the real world, and it's these new worlds that will define virtual worlds as *new* media for human expression.

What's new in the virtual is exactly what *isn't* shared with the real. It's what's unique to virtual worlds that defines them as a new medium: there's no material presence in a virtual world; virtual worlds are not bounded by the constraints of the physical world we know. To uncover the true potential of virtual worlds, we must master new paradigms. Exploring the unique qualities of virtual worlds is a departure point.

THERE'S NO *THERE* THERE

A special quality of a virtual world is its lack of actual presence. The virtual realm is an electronic environment built entirely of electrical signals translated into sensory experience. Even though the five senses may be immersed in a virtual world, the physical body always maintains its presence in the actual world.

Objects in the virtual world exist only within the computer. There is no material presence to the mountains that whoosh by in a virtual world. They have no tangible existence in the physical world. Like the images that flash on a television screen, the objects in a virtual world are only surface. They have no weight or mass. They can be viewed only on a computer display or with virtual-reality gear. While the experience may be immersive and seem realistic, even realistic virtual worlds are only experienced *as if* they were real. In fact, "there's no there there" (a phrase William Gibson borrowed from Gertrude Stein to describe cyberspace). This is a fundamental quality of the virtual that differentiates it from the real. Virtual worlds are ethereal.

FREE OF CONSTRAINT

If our reality is defined as a region in which cause-and-effect relationships are played out, then cyberspace represents a parallel reality where the laws of physics need not apply. Virtual worlds are not burdened by the structural dictates of the real world. Virtual worlds are not subject to the principles of ordinary space and time. A virtual world does not need to correspond to any real existing world. Michael Benedikt explains in his book *Cyberspace*:

> In patently unreal and artificial realities . . . the principles of ordinary space and time can . . . be violated with impunity. After all, the ancient worlds of magic, myth, and legend to which cyberspace is heir, as well as the modern worlds of fantasy fiction, movies, and cartoons, are replete with violations of the logic of everyday space and time: disappearances, underworlds, phantoms, warp speed travel,

mirrors and doors to alternate worlds, zero gravity, flattenings and reconstitutions, wormholes, scale inversions, and so on. And after all, why have cyberspace if we cannot (apparently) bend nature's rules there?

Virtual worlds can defy the precepts of physical space. Gravity need not exist. It's possible to travel at the speed of light. Time can be warped. A star system's millions of years of evolution can occur in seconds. Virtual worlds can recreate the earth of 200 million years ago.

I look around and see dinosaurs; I *am* a dinosaur. There is no reason why, in a virtual world, I must maintain human form. Given a mapping of my movements, my arms and legs become the wings of a pterodactyl. Instead of sitting in the canopy of a jet, I'm wearing a head-mounted display while hanging suspended from a sort of hammock. I experience the sensation of gliding through a magnificent mountainscape.

Our relationship to physical space and our known reality don't need to correspond with any familiar perspective. Not only can virtual worlds be realistic or imaginative, and defy the laws of physics, they can also transcend human physical and perceptual limitations. We are free to experience new worlds in completely new ways. Virtual worlds enable us to see the invisible, to shrink into microscopic worlds—we can go right down into the smallest molecule of the DNA helix—or, on a galactic scale, to travel through the solar system. "VR allows you to put your hands around the Milky Way, swim in the human bloodstream, or visit Alice in Wonderland," explains Nicholas Negroponte, director of the MIT Media Lab.

INFINITE RESOLUTION

There's no scale in the realm of the virtual. You can zoom in from a cosmic to a microscopic view, then zoom back out; you can travel in any given direction . . . endlessly. There's no limit to the resolution of a virtual construction. This unique quality of the virtual is a

necessary requirement for certain new digital worlds, such as the world of fractals discovered by Benoit Mandelbrot as a researcher at IBM's Thomas J. Watson Research Center.

From an early age, Mandelbrot developed an unusual approach to mathematics. He thought of mathematical problems in terms of shapes. Given a shape, he found that he could transform it in his mind, alter its symmetries, and derive a solution to the original problem. However, living in France, Mandelbrot found that French academia—dominated by a passion for abstract mathematics and, in particular, rejecting the use of pictures or geometry—was not receptive to his unusual mathematics. In an effort to escape from this restrictive atmosphere, he moved to the United States in 1958 to work for IBM.

At IBM's research center, he was free to pursue his visual approach to mathematics. Mandelbrot recalls, "I had this accumulation of geometric ideas dying to burst out of my head into other people's eyes." While most mathematics was becoming more and more abstract, Mandelbrot was looking for a concise way to describe complex natural objects, such as mountains, trees, clouds, and coastlines. Traditional geometry—with straight lines, circles, spheres, and cones—doesn't apply. In his book *The Fractal Geometry of Nature,* published in 1977, Mandelbrot explains how he "conceived and developed a new geometry of nature . . . [that] describes many of the irregular and fragmented patterns around us."

Mandelbrot's breakthrough geometry was based on what he called fractals. A fractal is completely "self-similar." A structure is repeated within itself *perfectly,* over and over with endless resolution, to create a larger, complex, and beautiful structure. The computer—and Mandelbrot's access to IBM's resources—made it possible to visualize fractals. "I could transform my geometric dreams." Mandelbrot could perform an easily programmed transformation over and over and over again. By the 1980s, his fractal geometry was being applied to problems in biology, physics, economics, geology, and a range of other disciplines.

Today, fractals are also being applied to create completely new

types of virtual worlds. For example, Brian Evans, an artist and musician working at the University of Tennessee, uses fractals to create abstract visual and sound structures. Ironically, given fractals' origin in describing the geometry of nature, Evans's fractal worlds are *not* like an experience of the natural world.

I look down into Evans's fractal as if perched on a virtual cliff. I prepare to do a "Mandelbrot Dive"—to jump directly into a fractal abyss.

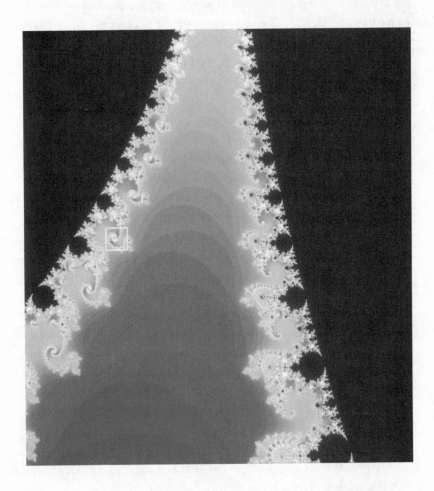

Thanks to the self-similar structure of fractals, I can zoom in for greater and greater resolution. I use a box outlined in white like a targeting system to pinpoint my next destination. With the touch of a keyboard I'm zooming in on the outlined box in the above image for twenty times the resolution:

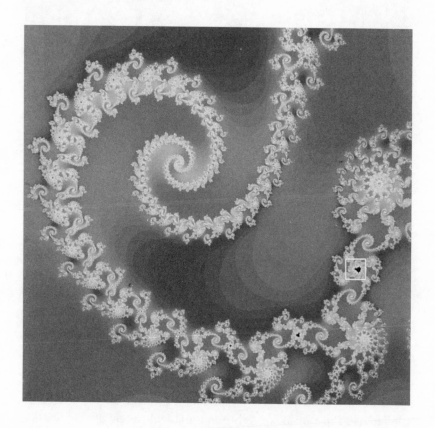

I can pinpoint and zoom over and over:

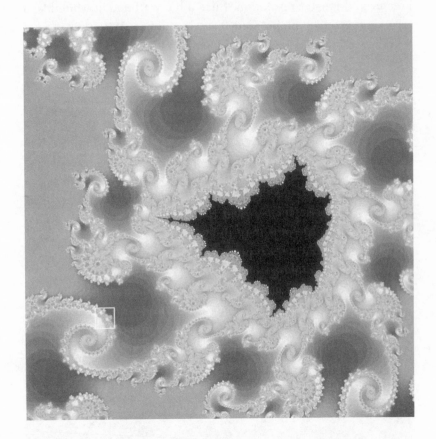

—forever. Zooming deeper and deeper, my speed accelerating, I am lost in a rush of psychedelic images as I move through infinite space. I'm not looking through a kaleidoscope at the swirling colors in front of me. I'm *in* the kaleidoscope. Immersed. Colors surround me.

Evans's computer system performs complex calculations to determine the color of each of the millions of dot elements in a fractal image. To create the animation sequence as I move through the fractal construction, thirty images are computed for each second. The computation required to achieve this brings a supercomputer to its knees.

Fractal worlds are, in effect, computation in visual form. They

don't have any soft edges. Each of the thirty images per second is the precise result of a staggeringly complex computation. Each image resolves to a discrete step in an endless iterative computation.

And fractals are entirely digital. They were inconceivable prior to the invention of the computer. Some mathematicians who influenced Mandelbrot had conceived of self-similar structures as early as 1915. But without the vast computational power of computers, they couldn't really visualize, much less experience, the rich and complex worlds that Mandelbrot discovered. Asked what we would know of fractals if not for the computer, Mandelbrot replied, "Nothing."

Fractals are not built on any borrowed metaphors. Flying through these abstract worlds of blinding colors is *not* like flying a jet through the mountains. Or like any other experience prior to the invention of the computer.

WITHOUT SCALE

The virtual represents an opportunity to explore what cannot exist in the real. This is exactly the goal of the virtual sculptor J. Michael James. His sculptures are dynamic fractal structures built from ordinary objects—fish, scarabs, condors, chameleons—in virtual space.

Trained as a traditional sculptor, he conceived of sculptures of fractal forms years ago. For one, entitled *Fractal Fish,* James tried to carve fish in lightweight plastics and suspend them by wires to create his complex structures. Unfortunately, the constraints of gravity and mass made this an impossible task. Now he creates his work in virtual space.

James explains, "It's impossible to create my fractal constructions in real space. But with a computer, it's possible to recreate that infinite richness. Virtual space, with its lack of gravity and lack of inherent scale, is the only place where I can build my sculptures."

Today, James's virtual sculpture *Fractal Fish* exists only in cyberspace. It's not a model of a sculpture intended for real space; the

virtual sculpture is itself the work of art. As I enter the virtual world of James's fractal sculpture, his fish swim shimmering under the surreal refracted light of an artificial salmon-colored sun. The sculpture is dynamic. The fish move through the ethereal space, sometimes above the water, sometimes below.

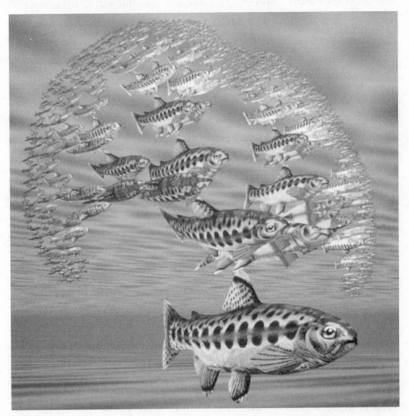

To create his sculpture, James repeats a fractal structure using an unlikely subject: a trout. With every application of the fractal rule, each trout produces two smaller ones, offset above the "parent" fish at 45-degree angles and reduced in size by 30 percent. The fish get smaller and smaller, like Russian nesting dolls. But the fish in James's sculpture fan outward, without end, always in tight fractal formation with military precision.

I swim around them, much as I might around a school of genuine fish in the waters of a lake in the Pacific Northwest. But these

are not ordinary fish in our familiar world. As I approach the edge
of the formation I soon realize that I'm swimming into what I've al-
ready seen before. James's fish—free of the constraints of the phys-
ical world we know—swim in abstract formations that can exist
only in cyberspace.

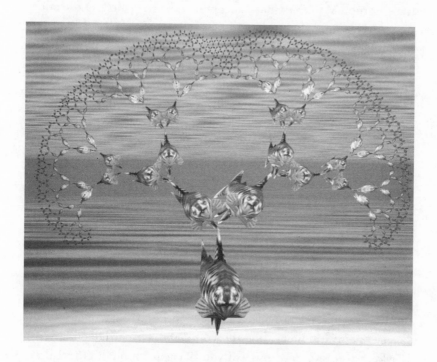

As a sculptor, James works in three dimensions rather than two.
Rather than displaying a projection of a two-dimensional image,
like the fish in a Berkeley Systems screen saver, the computer
screen is a window into his three-dimensional world. What's so dif-
ferent from a sculpture in the physical world is the sculpture's dy-
namic scale; I can examine its intricate structure as if it were a
Fabergé objet d'art or view its immense grandeur from the perspec-
tive of one of the smallest fish.

James's visual contradictions of everyday objects—like trout in
completely abstract fractal formation—have an Escher-like attrac-
tion. He is succeeding in his quest to redefine his art using the new
possibilities of his virtual medium.

THE NEWSPAPER OF THE FUTURE

If you use a computer today, you're probably familiar with the windows-icons-mouse-pointer interface (aka the WIMP interface) with computers, which has been around nearly since the birth of the Internet. While its mass acceptance began with the introduction of the Apple Macintosh personal computer in 1984, this method of interacting with a computer originated in the early 1970s at the Xerox Palo Alto Research Center. Today, with Microsoft Windows, it is the globally understood metaphor for organizing and navigating through information on a computer.

Widespread use of the Internet began in 1993, with the shipment of the first graphical Web browser, called Mosaic. Mosaic was the precursor to today's Web browsers such as Netscape Navigator and Microsoft Internet Explorer. Designed to run on WIMP-based computers such as Apple Macintosh, Microsoft Windows PCs, and Sun Microsystems workstations, the interface to the Web built directly on top of the existing WIMP world. But the multimedia worlds of the Web aren't suited to organization in a hierarchy of file folders. Today's WIMP interface, in which you point and click on words underlined with a blue line to move from one Web location to another, doesn't provide a context for your position in cyberspace. As a result, navigating the Web today, it's hard to get a sense of where you are. So, how will you navigate through ethereal cyberspace once you cross the thin blue line?

To find out, Earl Rennison, Nicolas Saint-Arnaud, and Lisa Strausfeld designed a three-dimensional interface that provides a new way of navigating the World Wide Web. Having developed a prototype "newspaper of the future" at the MIT Media Lab's Visible Language Workshop, they founded a software company in 1996 called Perspecta to implement their vision. (The company's other two founders were Nicholas Negroponte, as a member of the board of directors, and me. I joined as president and CEO.)

While Virtual San Francisco provides familiar navigation cues much as a desktop and file folders have provided a familiar inter-

face for Windows and the Macintosh, Rennison, Saint-Arnaud, and Strausfeld's interface points to new paradigms for navigating through information and even the chaotic World Wide Web.

I log on to the company's Web server to browse the news. To create an "information space," I provide a profile of the subjects I'm interested in and a list of Web sites that I like to visit. The Perspecta "server" then uses that information to scan the various Web sites I listed, as well as electronic news feeds from the Associated Press, Reuters, and other news organizations, to create a virtual space for me to explore. The space represents a three-dimensional map of the day's news. Rather than turn the pages of a paper, I fly through a virtual galaxy of news.

I scan my dashboard of navigation cues, point a virtual finger, and fly. As I approach the titles of different news subjects suspended in virtual space, lines make links among them immediately apparent.

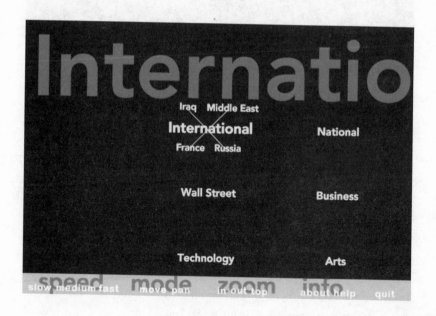

Reading a printed page, you hold something material in your hand. When you fly through the three-dimensional grid of news in cyberspace, the words have no material presence in the thin air of the virtual atmosphere. I veer toward the subject area of international news and it is highlighted as subcategories of news related to it emerge into view.

Densely clustered links fan out like the legs of a spider, connecting to related news stories. Lines stretch across the virtual map from Russia to national news. There are ties to stories on the financial markets, which in turn link back to Russia and the crashing value of the ruble. I am cast into the mediasphere, viewing a new dimension of information. The dynamic symbolic landscape exposes the structure of the news.

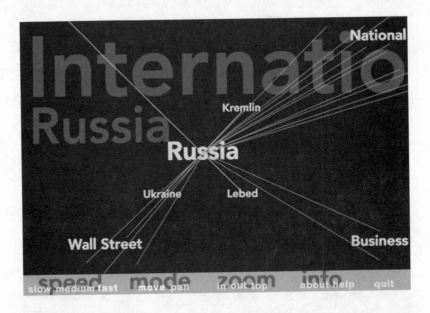

As I zoom in, headlines of specific articles now hang within visible range. Multiple Web pages are simultaneously accessed. The process isn't a mouse's point-and-click-on-a-single-pointer-to-a-single-destination, but a simultaneous view of myriad destinations in cyberspace. The three-dimensional cyberstructures made of text cues, floating images, and thumbnails provide me with an index of

Web sites. The mesh of subject titles and visual links is my map to the Internet.

I scan the headlines. A couple catch my eye, so I move toward them and stop. Yeltsin has fired Lebed. In an instant, the articles I'm interested in materialize before me, suspended in cyberspace. They could be anywhere on the World Wide Web.

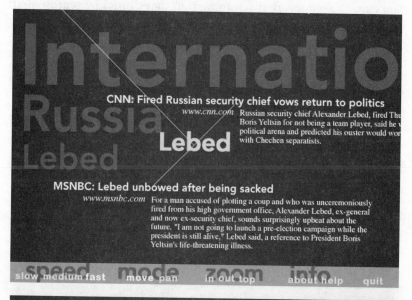

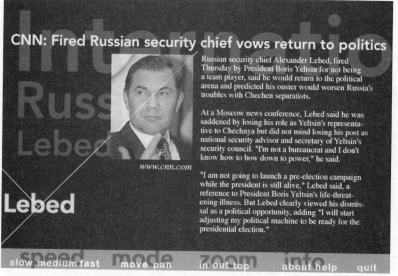

As if in a blend of a newspaper and television, the pictures are feeds of alternative views of the news event from MSNBC and CNN. I press a virtual control to animate the CNN report.

This isn't *The New York Times* or the hyperlinks of multimedia. It's information viewed in a format that exploits the totally new possibilities of digital media. Flying through this virtual newspaper, you can, at a glance, derive information that cannot be represented in two-dimensional print. The connections that tie together events of the day are clear. The complex web that binds world politics and finance is not an abstraction. It takes on a visible form. You are a navigator of the news as much as a reader. You're like a newspaper reader, but with a more active role.

It's easy to imagine that soon we'll share the view of a character in Alexander Besher's *RIM,* set in the year 2027.

> I take it our friend's still operating under various archaic assumptions, paradigms as obsolete as the daily headlines. Can't say I blame him though. You practically need to be an archaeologist just to read the newspaper these days.

ESCAPE FROM NATURE

In a colorful passage from *The American Replacement of Nature,* the cultural critic William Irwin Thompson worries that virtual reality is the culmination of the American dream of escape from nature.

> In truth, America is extremely uncomfortable with nature; hence its culturally sophisticated preference for the fake and nonnatural, from Cheez Whiz sprayed out of an aerosol can onto a Styrofoam potatoed chip, to Cool Whip smoothing out the absence of taste in those attractively red, genetically engineered monster strawberries. Any peasant with a dumb cow can make whipped cream, but it takes a chemical factory to make Cool Whip. It is the technological process and not the natural product that is important, and if it tastes bad, well, that's beside the point, for what that point is aimed at, is the escape from nature. In America, even the food is a moon shot, a fast food rocket aimed away from Earth. . . . History is replaced with movies, education is replaced with entertainment, and nature is re-

placed with technology. . . . At the edge of nature in the farthest West of America, it is no accident that the final act in the American replacement of nature should be the replacement of the body's incarnation into Virtual Reality.

His conclusions agree with what we have so far made of digital worlds: 99 percent of computer graphics seek photorealism, 99 percent of computer music research aims to recreate the perfect piano or trumpet, 99 percent of the work in virtual reality aims to simulate reality as perfectly as possible.

If virtual worlds are mere reflections of the natural, built on borrowed metaphors from the real world, then indeed we may create little more than the antithesis of the natural—the virtual Cheez Whiz that Thompson laments. We'll have the equivalent of a Jeff Koons ceramic sculpture—for example, his *Michael Jackson and Bubbles*—in the virtual world.

But this isn't the only path to be followed. In contrast, we can explore the differences between the virtual and the real. We can

free ourselves of the constraints of the world we live in to discover the essence of the virtual. We can exploit the unique qualities of digital worlds to unleash their full potential.

We need to discover the worlds we could never have known without computers. Fractals are such a *digital* world—a world inconceivable prior to the invention of the computer. We need to discard metaphors like "newspaper." The Perspecta "galaxy of news" represents a look at the future; it uses new paradigms to navigate digital worlds. We need to master the qualities of virtual worlds to develop new languages of expression. James's sculptures exploit virtual worlds' lack of scale to create dynamic three-dimensional fractal sculptures with infinite resolution. We must learn to sculpt the substance of cyberspace rather than clay.

Software Worlds

BUILDING A realistic virtual world rich with detail is a complex task. For example, imagine a mountain range. There are hundreds of peaks, each composed of a different rock. Some are craggy. Others are sheer. If you look closely at the rock face, it's possible to see the definition of every crack and fissure. At a lower elevation there are trees, perhaps even a forest. The forest as a whole can be seen from a distance of many miles. But when you're near, you can see every tree, every branch, even every leaf. You can get close to anything on the ground and examine the detail. Altogether, you can view the scene from an incalculable number of perspectives.

A painter might take days to render a *single* view with such richness and detail. Move to the other side of a canyon and a completely different view and, again, it would require days to paint. In fact, move just a few feet, or even a fraction of an inch, and yet other views appear that would take an equal amount of time to capture in full detail.

There is no way to create this scene by hand from more than a few points of view. Yet, if you're moving through a virtual world of rich images and intricate detail, two very high-resolution images (one for each eye's view, from a couple of inches apart) must be created every thirtieth of a second. In a virtual world, where it's possi-

ble to travel any path and view a world from millions of different perspectives, it's impossible to create the views manually.

So how does anyone create a virtual world and maintain a high degree of detail? By programming a computer. In the end, virtual-world designers don't create each specific view of the world you experience. They don't describe each mountain peak, each rock face, each tree, and each blade of grass. There's too much detail and too many possible views even to attempt to create a rich virtual world without the help of a computer. Rather, designers define the process through which the world is created. They specify the instructions to be followed to produce a virtual world. They write software that a computer executes to render the world you see and experience *at the moment when you experience it.*

Unlike any other expressive instrument we have had before, the computer represents a partner that can create expression—for example, virtual worlds, music, and even evolving artificial life—independent of the person who originally defines the software. It autonomously follows instructions in the form of software to create the virtual world you experience.

THE GEOMETRY OF NATURE

One of the challenges of creating virtual worlds with computers is finding efficient ways of describing complex forms. For example, natural objects can have incredible intricacy. It's impractical to describe a mountain in detail: each face, each valley and ravine, each stream and rivulet, and ultimately each clump of rocks, trees, and grass (not to mention the task of describing each blade of grass).

As I mentioned in the previous chapter, Mandelbrot's fractal geometry is a technique for describing the amorphous objects found in nature. Prior to fractal geometry, there was no concise way to describe complex natural objects such as mountains, trees, clouds, and coastlines. As a result, fractals have become a key foundation for building virtual worlds. They are exactly the sort of concise representations that virtual world creators need to describe elaborate worlds.

Fractals are "self-similar": small-scale details have the same geometrical characteristics as larger-scale features. A simple rule defined by the mathematician W. Sierpinski in 1915 illustrates how fractals work, creating what's known as Sierpinski's triangle. (Technically, it's a proto-fractal since Sierpinski created his rule before Mandelbrot developed fractal geometry.) Sierpinski's rule says: "Split each black triangle into four triangles by cutting out a white triangle in the middle." It's as simple as that. Yet Sierpinski's rule

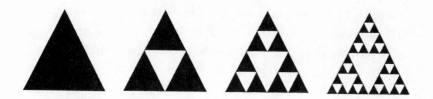

creates a sequence of self-similar triangular structures of rapidly increasing complexity.

You start with a solid black triangle. Applying Sierpinski's rule, you punch out a triangle in the middle to get the second structure in the sequence. If you apply the rule again to each of the three solid triangles, you create the third image in the sequence, and again, to get the fourth. As you repeat the process over and over, Sierpinski's triangle becomes more and more detailed. As we have seen, if the process is computerized it can continue without end.

The objects in nature, and the nature of virtual worlds, are three-dimensional. And the real power of fractal geometry is in describing three-dimensional shapes. A simple fractal rule defined by Alvy Ray Smith, a computer graphics pioneer, demonstrates this power.

Smith's rule is like Sierpinski's, but with a three-dimensional twist. Just as with Sierpinski's triangle, the rule starts with a single triangle. Smith's simple rule also splits this triangle into four triangles, but, in this case, the inner triangle is "pulled up" slightly to create a three-dimensional effect.

You can get a good sense of how this works by using a piece of paper. Cut out a triangle and draw three lines to create the initial four triangles on the flat paper. Then fold the lower corner triangles back and the top triangle forward. As in making origami, you immediately see the three-dimensional quality that emerges. This is then repeated again and again—which you can't do with paper but can easily do in a virtual world.

After applying Smith's rule a few times, you see the outline of a mountain start to form.

Repeat the rule a couple more times, and *voilà!* You have a mountain:

I still find it astonishing that such a simple rule can generate a realistic-looking mountain with intricate detail. With fractals, even a simple description can define the overall topology of a mountain range.

Fractals are an especially powerful class of rules for describing and generating complex visual structures, both realistic and abstract. When you get into the cockpit of a flight simulator, close the canopy, and fly through a realistic mountainscape, the computer creates the world that swooshes past you with fractals described in the form of software. When you fly into Brian Evans's abstract fractal construction, zoom in farther and farther, zoom back out, and travel in any given direction endlessly, the computer creates the world you see from a fractal description programmed in software.

EVOLVING NATURAL FORMS

Fractal worlds are static. The landscape in the flight simulator doesn't change over time. Evans's abstract fractal construction

doesn't, either. It's your view of it that changes as you fly through fractal space. However, other types of rules can describe how things change over time. They can animate worlds, and computer-generated worlds become particularly interesting when they change over time—when they can grow and evolve in unpredictable ways.

Here again, the challenge is finding efficient ways to describe complex—and *evolving*—forms. With this in mind, a group of scientists have been looking for simple ways to describe complex real-world behavior. Pursuing what they call A-life (artificial life), they share a belief that life's workings are founded in logic. They base their work on what is referred to as emergent behavior; a fundamental objective of their work is to demonstrate how seemingly complex behavior found in the world around us can emerge from simple rules.

Stephen Wolfram was one of the first prominent A-life scientists. A mathematics and physics prodigy, Wolfram studied at Oxford University, received his Ph.D. by the age of twenty from the California Institute of Technology, and later went on to found the software company Wolfram Research. But, among his numerous achievements, Wolfram told me, "What I'm proudest of is my work with computers demonstrating what simple programs can do—how great complexity can result from very simple programs." In 1982 he helped to establish a foundation for artificial-life research by demonstrating how complexity can result from simple input.

Wolfram wanted to expose some of the underlying rules of nature. Bubbling with obvious enthusiasm for the possibilities, he explained to me what he saw as the challenge: "I wanted to learn about nature's secrets. We can immediately tell the difference between artifacts and natural objects. What's the secret that nature has that we humans don't understand? Our intuition would say that if the rules are simple then the results will be simple. Our intuition also would say that, since the world of nature is complex, the underlying rules of nature must be complex. As a result, no one before me bothered to experiment with the idea of creating complex systems from simple rules."

He used the computer to pursue his experiments. Relying on the computer as his partner in his search was, to Wolfram, an obvious thing to do. "I started playing with computers when I was a kid, at thirteen or fourteen, in the early 1970s. It was natural for me to study whatever I was going to study on the computer."

In his first experiments to create what he calls "cellular automata," Wolfram defined a set of rules that determines how a row of "cells" evolves over time. Given a row of cells, a second row—or "generation"—is created by following his simple rules. Wolfram started by defining each cell as a square that is either on (black) or off (white).

He then listed the different combinations of cells. For example, for a group of three cells, there are eight possible combinations of black and white cells—three black cells; two black cells and one white cell; black-white-black; and so on.

For each combination of three cells in a generation (the first row below), Wolfram's rules visually illustrate the "descendant" that results in the next generation (the second row):

For example, given three black cells (the first combination above), the middle cell in the next generation will be white. Similarly, given three white cells (the last combination above), the middle cell in the next generation will also be white. On the other hand, a black cell followed by two white cells (the fourth combination) or a white cell followed by two black cells (the fifth combination) generates a black cell.

Starting with a single seed row, Wolfram's rules create successive generations. Initiated with a row including only one black square, the rules produce the following five generations:

Fifty generations:

And one hundred generations:

The rules quickly "grow" intricate patterns that are not unlike patterns found in nature. In fact, after Wolfram published his first papers, people sent him seashells with patterns that looked as if they came right off his computer screen. Wolfram's rules for artificial life seem to mimic nature's rules for real life.

Even Wolfram was surprised by the significance of his results. "I thought that the result was so simple, someone must have done this before. I'm sure that if Alan Turing [who established the theoretical foundation for computing in 1936] had had a personal computer, he would have discovered all of this twenty-five years before I did. But, before computers were commonplace, it was impossible to imagine how simple rules could create complex forms. Nonethe-

less, I'd not be surprised if someone someday discovers a Roman mosaic that looks like it was created with CAs [cellular automata]."

Wolfram's cellular automata demonstrated for the first time how complexity could emerge from a simple set of rules. Not only did he show how these rules could create rich visual imagery, but the results of his early experiments suggested that such rules might also be at work in nature—that the complex world around us might have arisen from relatively simple rules. Wolfram's experiments are far from completed. As he says, "Right now, there are still lots of wide-open questions to explore. What are the basic programming methodologies that living systems use? Did nature discover recursion? Did nature discover object-oriented programming?"

PROGRAM MUSIC

Wolfram's rules generate visual forms that evolve over time. My inclination to music has always made me think of music as sound structures that evolve over time. As a result, the idea of using a computer to create musical forms has long been of interest to me. In fact, I was first introduced to the concept in 1976 when I studied with the German composer Gottfried Michael Koenig at the Institute of Sonology in Holland. In the early 1960s, Koenig wrote the first sophisticated music-composition programs.

At the time I studied with him, Koenig was primarily known as one of the pioneers of electronic music. He had collaborated with the composer Karlheinz Stockhausen in Cologne in the late 1950s to create the landmark electronic works "Gesang der Jünglinge" and "Kontakte"—considered the first accomplished works in the medium of electronic music. Koenig lectured in a room that held about twenty students. The view out the window—a centuries-old clock tower across a cobbled street and a canal—was a stark contrast to his radical discourse.

Koenig described the West German Radio studio where he and Stockhausen had worked. "It was a remarkably simple studio. The only sound source was a single sine-wave generator. There were

also three single-track tape machines. To create electronic works, we set the sine-wave generator to various frequencies and recorded them on tape. Then we cut up the tapes in various lengths—the studio was covered with piles and piles of tapes—and we mixed a couple to create richer sounds from two simpler ones. We repeated this process many times to create even more complex electronic sounds. It was a long and tedious process. In fact, it took us months to create each piece."

At first I was rather surprised that, as one of the pioneers of electronic music in the 1950s, Koenig also developed a totally new approach to composing music with computers. It's rare for an artist or even a scientist to make breakthroughs in areas requiring such different approaches. But as I listened to him explain the techniques of his early days in the electronic studios, it began to make sense to me.

When Koenig composed the unusual score for his electronic work "Essay," published in 1960, he wrote down in precise detail all the instructions required to create the piece in an electronic music studio—the frequencies to be recorded, the lengths of tapes, how they should be ordered and combined, and so on. Koenig explained, "It's like the score for a piece of traditional instrumental music. 'Essay' indicates to a performer exactly what they need to do to create the music I intended."

When he discovered computers in the early 1960s, Koenig found it natural to program a computer with the rules of his composition process. He thought a computer could accurately follow his instructions to create his music. "'Essay' was like a computer program. It was a precise set of instructions to be followed to create my music. In fact, all my instrumental and electronic pieces are produced according to rules for composition. I only had to formalize those rules more carefully to use a computer."

Koenig's goal was to have the computer write music autonomously, just like a musician performing from his score. But in this case, the computer writes the music, which is then performed by a musician. "I'm not interested in computer-*aided* composition but rather computer composition. I try to formalize the compositional

rules and then let the computer completely take over." It was a radical new way to write music. "I had to invent music again in terms of programmable processes. I had to think up different strategies that could be programmed with the computer."

A PARTNERSHIP

Defining rules and bounding new worlds represents an entirely new form of expression for which Mandelbrot, Wolfram, Koenig, and others have established a foundation. What only a short while ago seemed like a radical approach now is becoming accepted as natural. More and more scientists, artists, and other creative spirits are beginning to explore new worlds whose creation was made possible by teaming up with a computer.

Wolfram thinks of the computer as a new type of tool that lets him explore the possibilities of various rule sets. "I found that, at the time I first started working with computers, scientifically oriented people didn't think of working with computers to discover things. But I could not have done my work without computers. In particular, my efforts in the last five years have been to use Mathematica [technical computing software developed by his company] to do computer experiments. I take a model to the computer and try out different things. I can't predict if the results will be interesting. I work with the computer to find out. It's a new way of experimenting."

Describing this new creative partnership, Koenig explains: "Writing music in this way—I'm creating works of art of a completely new kind. It's a new category not known before. The computer is not composing alone; the computer needs a program and the program has to be written by a composer. The composer is the one who composes, not the computer. But the code has to be put into action, which only the computer can do. It's a partnership— the computer is an intermediary between the composer and the end product. The composer today is not only one who can write a piece of music but also one who can write a program that can produce music."

The power of this new creative process is that, from a single set of rules, the computer can create many dynamic and evolving digital worlds. Koenig elaborates, "My programs weren't intended to produce only one piece of music. Programming a computer is a creative process, which can then multiply itself into a multitude of compositions."

Following in the path Koenig established, more and more composers, myself included, are exploring the use of computers as a new way of composing. I have used the computer as a partner to write compositions for the piano, the harp, and computer-generated sounds. One of the most startling music-composition programs I've seen was developed by the composer David Cope, working at the University of California–Santa Cruz. Cope's computer composition system analyzes the work of various composers to derive their compositional rules. You feed in a number of examples of a composer's music, and his software then creates new music following their rules. For example, after analyzing the music of J. S. Bach, Cope's composing software writes music that I might easily mistake for Bach's. Likewise, Cope demonstrated to me how his system produces *original* compositions in the styles of Mozart, Chopin, Scott Joplin, and others.

Yet I have found over and over again that the very idea of a computer writing music horrifies many people. A computer composing Mozart? People readily accept that computers can be taught to play chess—and that they can play very well indeed, as the "Big Blue" computer demonstrated against world chess champion Gary Kasparov in 1996. However, people cannot easily accept computers in the sacrosanct domain of human creativity. But the participation of computers in the creative process is inevitable.

Minimally, computers will be used to generate the details of virtual worlds that it would be impossible to create without them. But far more intriguing is using computers to build entirely new worlds. Ironically, although the idea that computers may be able to recreate the style of Mozart always seems to evoke a strong reaction, it is, I believe, only interesting from the point of view of musicology and the study of Mozart. In any case, I don't think Mozart's genius

will in any way be threatened even if computers help make the rules of his music more explicit. By analogy, even if the work of Wolfram and other artificial-life researchers sheds light on the secrets of nature, I doubt that we will regard the beauty of nature with any less awe.

To me, the most exciting aspect of using computers as creative partners is the possibility of creating completely new worlds, worlds unimaginable before computers. Although software systems can be used to create instrumental music, painting, and other predigital art forms, we were expressing ourselves in those forms long before the computer existed. Obviously, it's possible to compose music and to paint without the computer as a creative partner. However, it isn't possible to create a complex digital world. The complexity of a virtual world requires that a computer be programmed as a tool to create it. Exploring fractals and artificial life necessitates collaboration with a computer as a creative partner.

In the future, rather than producing fixed expressions, software designers and artists will define processes in the form of software to create "worlds" to be explored. They will program rules that will determine what shapes and forms can exist and how they will evolve over time. A set of rules, set in motion with a computer, will produce a rich set of possibilities—possibilities not predetermined in any traditional way.

These are truly digital worlds—they cannot exist without a computer. Like music printed on a page, which is only ink on paper until an orchestra plays it, the processes described in the form of software are static until a computer brings them to life. These worlds exist only as long as binary processes flow across digital circuits. Such worlds represent vistas of entirely uncharted possibilities, while software designers are the new alchemists, looking for formulas that transform bits into gold. We're on the verge of a new age in creativity—an age in which the software is the art.

4

Animated Worlds

To SOME people the idea of the computer as an autonomous partner still seems like an affront to human creativity. Yet the idea of *not* using a computer in the creative process will soon seem like an anachronism. As television, movies, and other traditional media become more and more dominated by on-line digital media and virtual worlds, the importance of software will continue to grow. Soon the artists who create digital worlds will be as celebrated as rock stars. Already the credits of most Hollywood movies today include software designers.

As we master the use of software for expressive ends, the autonomy with which it acts will also increase dramatically. Digital pioneers are radically expanding the definition of autonomy. They're developing technologies that enable computers to act as "autonomous agents" and display "intelligent behaviors." These technologies will change the nature of digital worlds. Instead of static worlds, we'll discover worlds populated with a variety of "digital actors." We'll interact with digital creatures, and we'll have no doubt that they are endowed with some sort of intelligence. They'll respond to us and develop very sophisticated behaviors. We're witnesses to a time when digital worlds are truly coming to "life."

FLOCKING IN FORMATION

How can intelligent behaviors be captured in the form of software? The flocking behavior of birds is an example. Have you ever watched in amazement as a cluster of birds suddenly takes off and almost instantly assumes formation? In the early 1980s, a computer-graphics animator, Craig Reynolds, did. While ornithologists had no explanation for how this happened, Reynolds was convinced he could write a computer program with a simple set of rules that could model the behavior of flocking birds.

Reynolds's fascination with the idea of creating rich simulated worlds dates from his childhood. "When I was little, I played with toy trains. I loved the idea of building worlds that could then run themselves. I would take kits with trains, people, buildings, and so on, design a 'world,' wind it up, and leave it to itself. When I learned programming, I realized I could do this with a computer." Later, as an adept software programmer in his twenties, he had the idea of using a computer to simulate the behavior of flocking birds. "Years ago, I was sitting in a cemetery near where I worked. I was watching a group of birds take flight when the idea of simulating flocking first came to me. An individual bird flying is pretty interesting, but a flock of them in formation is *very* cool."

Even though the behavior of a flock looks as if it's coordinated by a centralized control, Reynolds speculated that it somehow emerges from the independent actions of each bird. "The motion of a flock of birds is simple in concept. Yet as I watched the birds take off, the flock's motion was so visually complex it seemed randomly arrayed, while at the same time it was magnificently synchronous. Perhaps what's most puzzling about a flock is the strong impression of intentional centralized control. But I couldn't imagine how it could be centrally coordinated. All evidence suggested that flock motion had to be merely the aggregate result of the actions of the individual birds, each acting solely on the basis of its local perception of the world. I concluded that there must be some fairly simple description of the behavior of birds in a flock."

Reynolds started by creating "boids"—short for "birdoids" or fly-

ing objects in virtual space (no, it's not Brooklynese). In his initial experiments, these were simple geometric objects that looked somewhat like miniature Stealth bombers. Reynolds then defined a simple set of rules to control their movements. "I defined flock behavior in terms of the opposing forces of collision avoidance and the urge to join the flock. I characterized this as three simple guiding principles. Flock centering: attempt to stay close to nearby flock mates. Collision avoidance: avoid collisions with nearby flock mates. Velocity matching: attempt to match the velocity of nearby flock mates."

Under Reynolds's rules, each boid takes note only of its neighbors and then applies that information to its own actions in the next time step. Its urge to join the flock moves a boid toward the flock's center of gravity—for example, if other boids are to the left, it moves left. On the other hand, its collision-avoidance instinct instructs a boid to move away if another boid is getting too close. Lastly, each boid matches its speed to that of nearby boids, unless it is required to slow down or speed up to stay near the flock.

With just these three simple rules, Reynolds's boids did indeed simulate the behavior of flocking birds. "Sure enough, I wrote the code and the boids acted like a flock." Even Reynolds was amazed when, in his first experiments, the boids formed a flock, broke into two when confronted with obstacles in their path, and then rejoined in flock formation as if by instinct—all by following only his simple set of rules.

What's particularly noteworthy about Reynolds's rules is that no single program directs all the boids. Each boid individually follows the rules and reacts only to its local situation. It's a decentralized activity. The behavior of the *whole* flock emerges from simple rules followed by each boid independently. It isn't programmed in. It magically arises from the behavior of each individual. The whole is more than the sum of its parts.

Reynolds likes experiencing flocking from a bird's point of view. "What I like most about my work with flocking is the change in perspective—from viewing a flock from the outside to a perspective of what it must be like to be in a flock. It's somewhat like cars in traffic. Observing the overall traffic from on top of a hill, the cars all seem to be conforming to the same pattern; they're all moving along at the same speed, and so on. But if you're in the car, you make all sorts of little corrective decisions, steering to avoid the car to your left or right, accelerating and braking. It's as though the world is rotating around you. That's the perspective I get from my work with flocking birds—what it's like to be *in* the flock."

Others have taken a keen interest in Reynolds's work. For example, the boids were able to flock in large configurations so convincingly that ornithologists wanted to know Reynolds's rules, and the rules have also been applied to model the behavior of schools of fish and herds of animals.

Reynolds's techniques have even become part of Hollywood's bag of tricks. You've probably seen his work in action: his flocking algorithms are the basis for the realistic swarm of bats in the opening of *Batman Returns* as well as for the multitudes of penguins converging on Gotham City in the closing scenes. Reynolds's other film credits include another bat scene, in Sylvester Stallone's *Cliffhanger,* and the opening scenes in Dreamworks SKG's forthcoming animated film *Prince of Egypt*. His work illustrates how simple rules can create the complex emergent behaviors of real living systems and how, following the rules, computers can animate artificial worlds.

AMBIENT SOUNDS

Of course, the world we live in is filled not only with visual imagery, but also with sounds. The Canadian composer Barry Truax has spent the last twenty years studying the rich sound textures found in the natural world. He also uses the computer to create dynamic sound textures in the same way computers generate evolving virtual worlds.

Truax lives surrounded by snowcapped mountains and the Pacific in the beautiful city of Vancouver in British Columbia. He is passionate about environmental sounds—listening to them, recording them, analyzing them, and synthesizing them. He's a member of Vancouver's Urban Noise Task Force and the World Forum for Acoustic Ecology, and he has spent years directing the World Soundscape Project at Simon Fraser University, a massive effort to record and preserve the sound environments of everything from rainforests to seashores to cities.

"The goal of the project is to preserve and protect sound environments," says Truax. "We're documenting acoustic environments and raising awareness of our sound ecology. We want to understand what is positively valued. What sound environments enhance our life?" Touring his studio, I passed walls filled with hundreds of tapes of different soundscapes collected around the world. Reading some of the labels—"Vancouver 1970s," "Vancouver 1990s," "European Alps"—I tried to imagine what the world sounded like a hundred years ago.

While visiting his digital studio, I realized that Truax's fascination with natural sound environments carries over into his own computer-generated compositions. He strives to create the natural textures of the sound worlds documented in his libraries of tapes. "I always felt computer sounds were artificial. I wanted to create more lifelike sounds. What is it about environmental sounds that make them so breathtaking?"

In his "Riverrun," for example, Truax programmed a computer to capture the natural sound patterns of a river. As I listen, I hear single droplets: *"tup . . . tup . . . tap . . ."* I visualize the first droplets of snow melting at a source high in the mountains. Slowly, more

and more droplets accumulate and it sounds as if it's beginning to rain: *"tup tap tap tup . . ."* The gap between the drops narrows until there is a continuous patter: *"tuptap-taptuptup-tap-tupataptup."* The frequency increases. There are hundreds and then thousands of events. I imagine a rivulet, and then a stream rushing into a cataract. It gushes like pouring rain: *"tupataptupatupatap . . ."* Soon I can no longer differentiate the sounds of the individual droplets. I can hear only a dense sound texture. The river grows into a force that can cut magnificent gorges and waterfalls. The sound increases not so much in loudness as in magnitude. Then, as the crescendo plateaus, the sound seems to stretch out in time, like the aural equivalent of slow motion film. Suddenly, I feel as if I'm sitting *inside* a massive waterfall. As time seems to come to a standstill, I hear every microlevel detail, every microvariation. I'm absorbed into every micromoment of the thunder.

Truax's statistical techniques produce these patterns from countless "droplets" of sound. He creates what he calls grains of sound, tiny snippets of sound that last less than a twentieth of a second, and then defines general distributions of these tiny grains in terms of what are known as stochastic formulas. He lets the computer calculate the details. "I guide the process rather than control the details." There's lots of detail to the texture. At the peak density, several thousand grains are sounding per second.

Finally, the intensity of the sound ebbs away. The river widens into a kind of drone, just as the Fraser and Columbia broaden as they cross the lowlands to the Pacific. The textures have an organic feel. They seem natural, like the sound of a river, or rain, or hundreds of crickets, or a squawking flock of birds. But they're not. Rather, they're the sort of computer-generated sounds that will bring rich aural textures to future digital worlds.

BREEDING ARTIFICIAL LIFE

If software represents an opportunity to open up new vistas, the possibilities are clearly illustrated by Karl Sims's virtual worlds filled with artificial life. Sims has spent the past fifteen years

searching for new ways to use the computer as part of his creative process. "The idea that computers will help us in the inventing process is a hard concept, but it's one I've set out to explore."

Sims studied biology at MIT before he was introduced to computers at the MIT Media Lab. But it was when he moved to Hollywood after he left MIT that he first developed his reputation for creating stunning visual imagery. Hollywood was also where he first started to use the computer as a creative partner. Sims explains, "I've always been interested in getting computers to do the work. While I worked in Hollywood, I was doing animations with details that no one would ever want to do by hand. For example, I used a computer to create an animated waterfall, when I could never have designed each drop of water for each frame in the animation. Instead, I created it with a completely procedural method"—that is, he created a general description of the waterfall and then let the computer generate the waterfall itself. As if in a visual equivalent to Truax's riverlike sound textures, hundreds of thousands of drops of water make up each image in the animation.

While Sims produced striking images in Hollywood, his more recent work stimulates the imagination with mind-boggling visions of future digital worlds. After a few years in Hollywood, Sims was invited to work as the artist-in-residence at the Cambridge-based company Thinking Machines. Danny Hillis, the founder of Thinking Machines and an artificial-life enthusiast, hired Sims to show off the power of the supercomputer Hillis had designed. Hillis's Connection Machine was the first "massively parallel" supercomputer, featuring over 65,000 processors that worked in parallel. He developed the foundation for his computer's architecture from the idea of distributing a simple task to independent processors to create complex results. His computer's architecture shares a philosophical perspective with the modeling of artificial life, with complex behavior emerging from simple independent activities. Hillis offered Sims unlimited access to some of the fastest supercomputers on the planet and gave him the latitude to take them to the limit.

At Thinking Machines, Sims created eye-popping worlds filled with evolving artificial life. In order to produce computer graphics duplicating the complexity of the real world, Sims thought it made sense to use nature's techniques for generating complicated objects. Rather than design artificial worlds, he decided to "grow" them.

Sims clarified his interest in artificial life: "I came to artificial life because it was useful for my computer graphics, not as a theoretical research project. I was struggling to create some new forms of plants for an animation I was working on called *Panspermia*. That's when I decided to use the computer not just to fill in the details but to develop an 'evolution tool.' Evolution has led to the creation of incredible complexity—including ourselves and the other organisms in the world. No one assembled all the wonderful things in the world. They were created by genetic processes. It occurred to me that computers could simulate this process and we could get all of these complicated and interesting things without having to understand and assemble them. I decided to 'grow' new forms of plants."

Sims created a variation on what are known as genetic algorithms—sets of instructions, in the form of software, that control the development of a virtual "organism," rather as DNA contains the instructions for the development of a biological organism. For example, to grow trees and plants in his artificial worlds he used genetic algorithms that determined branching, growth rate, twistiness, and budding. He evaluated the results created by a pair of genotypes, selected a pair from the offspring as the "best of breed," and then had the computer generate another generation.

"Do you want to type in the instructions over and over as you refine your description of a plant? No. You want to evolve them. I thought, Why not use the computer to generate the possibilities while I act in the selective process? I use the computer to generate the results from various groups of instructions and then look at the results and pick the ones I like: No, this one isn't interesting; no, this one isn't good; but this one is! For a given 'generation,' I pick a pair of plants that I like and these then become the parents for the next generation."

In the following example, Sims selected two plants from one generation as "parents" for the next. One is squat, with chunky leaves; the second is tall, with short fronds.

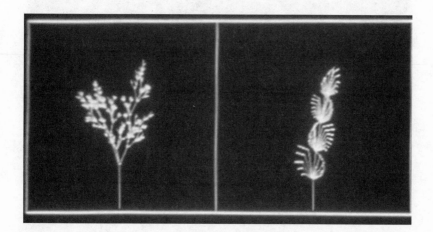

The subsequent generation of offspring is automatically generated by the computer, which follows the instructions encoded in each of the parent plants' genes and adds a degree of random mutation to ensure varied (and, it's hoped, interesting) results.

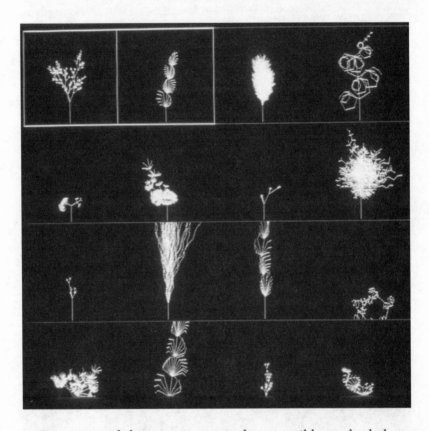

Sims repeated this process over and over until he evolved plants that he was happy with. "Let the computer do the random part, let the human do the aesthetic part. It's a great process, the ideal way to grow these plants. I think of it as Darwinian. It's survival of the fittest. In this case the fittest is what I think is aesthetically pleasing."

While visiting Sims in Cambridge, I observed how, with a few clicks of his keyboard, he varies the parameters that determine the mix of his artificial genes. The trees and other plants that result from his process include both realistic ones and new strains never seen before.

I watch his artificial world change from one moment to the next. It's alive: Artificial life-forms grow and reproduce by genetic processes. More complex life-forms evolve from earlier ones. With wonder, I observe the world evolving in virtual space.

Sims pauses the program and loads another library of genotypes, then explores using genotypes not modeled to behave like anything in our natural world. Otherworldly life-forms grow and evolve according to the rules of completely new genetic codes. The artificial life-forms glisten with the reflective quality of ice. They cling together in tight clusters that undulate like the rolling waves of the ocean, in slow motion.

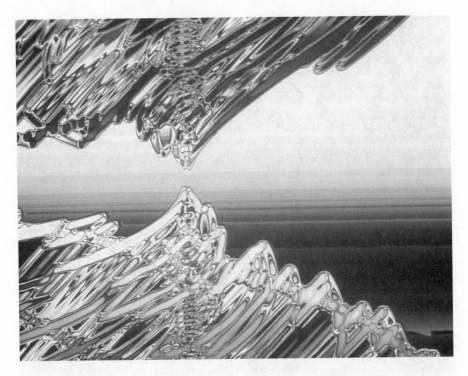

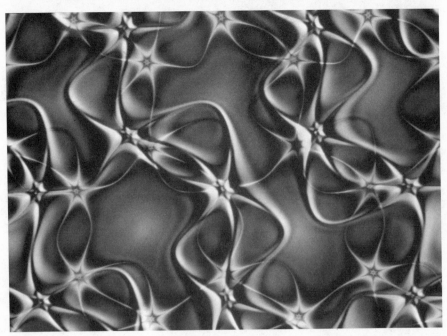

In yet another artificial world, governed by its own unique genetic codes, starfishlike creatures emerge from and then disappear back into a dense mud as they are born, live, and die. To see them is like watching life emerge from a primordial soup, brewing new shapes and forms.

In his virtual petri dish, Sims creates living, evolving artificial worlds that represent entirely new virtual realms to explore.

LEARNING TO SWIM AND WALK

More recently, Sims has enhanced his genetic systems to evolve "creatures"—objects with both bodies and the capacity to develop intelligent behaviors that evolve over time. Just as with his techniques for growing "plants," he specified instructions for evolving the development of the organisms, and added movements and intelligent behaviors that could also evolve. Rather than act as the referee making the selection of the "fittest" from one generation to the next, Sims established goals, then let the computer automatically score how well offspring in a generation met the goal, select the most fit offspring, and produce the next generation. "I soon realized it's much harder to watch creatures and pick, so I let the computer evolve them, look at the results, and throw them back into the genetic pool. It's much more like biological breeding." The results are astonishing.

Sims's creatures are composed of simple blocklike body parts connected by joints that have a variety of ranges of motion. The body parts also have sensors that can detect the angle of the joints or contact. A central nervous system processes the sensory input and then directs the muscles how to move. Sims leaves it to the computer to decide how the parts should be assembled and used in any given creature.

Sims then defined "fitness measures" by which the creatures' development of locomotion strategies could be evaluated independently by the computer. For example, a fitness measure for swimming looks at speed, and also favors straight swimming over circling, continuous movement over a discrete push, and so on.

Sims initiated his program with a single creature in a pool of simulated water. It twitched but didn't go anywhere. The computer then created a new generation with random mutations, 300 offspring in all. Each of the offspring then got a swimming test, and the best swimmers were selected as the basis for the next generation.

"When the computer makes mutations in the genes of these creatures, it has no idea what these mutations are going to do. Sometimes the mutations might knock out a piece of the nervous system so the muscles don't move anymore. But other mutations might actually improve the motion."

Within a few generations, the swimming fitness measure quickly—and without human intervention—produced a large number of paddling and tail-wagging creatures. After a few more generations, a variety of rather sophisticated strategies began to emerge: some creatures had two symmetrical flippers to propel themselves; others evolved large numbers of flippers.

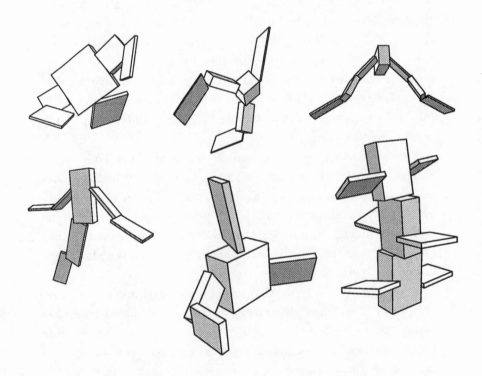

But the clear winner was a multisegmented snakelike creature that winds through the water with sinusoidal motions.

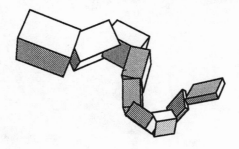

Placed on land, the water snake was like . . . a fish out of water. But within a few generations Sims's system quickly evolved creatures that could shuffle or hobble along at fairly high speeds. After a few more generations, some of the creatures walked with lizard-like gaits while others simply wagged an appendage in the air to rock back and forth in just the right manner to move forward. Still others pushed or pulled themselves along inchworm style. Even some hopping creatures emerged.

Some of the results were impossible to predict. "Sometimes the evolving creatures would think of solutions completely different than what I expected. In this one example, the creatures got taller and taller and taller and would simply fall over. Instead of figuring out some clever way of walking, they would fall to generate horizontal velocity. What I was telling them to do was just to move, and falling was a perfectly reasonable solution as far as they were concerned. So this creature specialized in falling for as long as it possibly could, including doing a complete somersault."

COMPETING FOR GOLD

Sims then switched to a completely different environment. Here, two creatures were positioned at opposite ends of an open space and a single cube was placed in the middle. Sims explained that in this case the goal established a competition between the two creatures. Whichever creature got to and maintained control over the cube first won. He started the evolution process.

As the gladiators were set in motion, Sims elaborated on what was happening. "Some species take many generations before they can even reach the cube at all, while others discover a fairly successful strategy in the first ten or twenty generations." A variety of methods appeared for reaching the cube. Some creatures extend arms out onto the cube, while others reach out while falling forward, to land on top of it. Still others crawl inchworm-style toward the cube, while others have developed leglike appendages.

What was most interesting was how the species developed strategies to counter an opponent's behavior. Some creatures learned to push their opponent away from the cube, while others moved the cube away from their opponents. One of the more humorous approaches was a large creature that would simply fall on top of the cube and cover it up, so its opponent couldn't get to it. Some counterstrategies took advantage of a specific weakness in the original strategy but could be foiled easily in a few generations by adaptations in the original strategy. Others permanently defeated the original strategy.

The power of Sims's artificial evolution is its ability to come up with solutions we couldn't otherwise imagine. "When you witness the process, you get to see how things slowly evolve, then quickly evolve, get stuck, and then get going again. Mutation, selection, mutation, selection, mutation, selection—the process represents the ability to surpass the complexity that we can handle with traditional design techniques. Using the computer, you can go past the complexity we could otherwise handle; you can go beyond equations we can even understand." Sims's awe-inspiring work points to a future where evolving artificial and intelligent life-forms will populate vibrant digital worlds.

I WANT MY MTV

Unlike the computer-generated visual images and behaviors that are becoming part of Hollywood's special-effects arsenal, the mainstream application of sound- and music-generation systems remains elusive. The music on MTV has yet to go auto-digital. There are only a few examples of computer-generated music approachable by a broad audience. Todd Rundgren's CD-ROM *New World Order* is one of those rare examples. The music of Brian Eno is another. Both Rundgren and Eno are advocates of the idea that art is more meaningful as an evolving process than as a packaged product.

Rundgren's CD-ROM is an experiment in a new type of music that involves the listener in its performance. Rundgren recorded the material for a song—lyrics, themes, instrumentation—at a variety of speeds and moods. Then, for each of a number of songs, the listener specifies qualities for a performance—fast or slow, happy or sad—and the computer creates a specific interpretation selecting from the segments Rundgren has recorded. Each song is performed according to the listener's instructions. Depending on these instructions, a different path is followed through the many musical permutations that make up *New World Order*. This is a relatively narrow field of musical space to explore. Nonetheless, it points to a

future in which musicians don't release static recordings but rather give you the tools to set in motion your own customized musical experience.

Eno's recent work takes the idea of music as an evolving process even further. Eno, one of the founding members of the British "glam rock" group Roxy Music in the 1970s, today is one of the most influential producers in rock music. He's worked with David Bowie, Laurie Anderson, U2, and many others. He's also the godfather of ambient music, which he calls "as ignorable as it is interesting."

In his ambient music, Eno created rich textures from long-sustained sounds created by automated electronic processes. Once set in motion, his processes were left to do their thing. "For years, I have been using rules to write music. . . . My rules were designed to try to make a kind of music I couldn't predict. That's to say, I wanted to construct 'machines' that would make music for me."

Eno's application of his processes to U2's music to create a rough machine sound is very unlike the driftspace of his ambient mood music. On the group's *Zooropa*, a tape loop generating a rhythm out of static, noise, and hiss is audible. It's U2's "Berlin sound"—and it has Eno's touch.

Until recently, Eno didn't use a computer to control his processes. However, since 1995, he has collaborated with Tim Cole to do exactly that. Over the past several years, Cole has developed Koan Music software for "ever-changing interactive music." Cole explains that "Koan Music can be thought of as being comparable to a ball bearing traveling down a guide or chute. Each time the ball bearing makes a journey it will travel a different path, but the available path is constrained by the chute." The composer sets the constraints by setting the values for approximately 150 controls in the Koan system. Following the rules, the Koan system—in effect, a music improvisation system—then composes and harmonizes in real time for as long as the computer is left to do so.

Eno released his first set of "pieces" in 1996. "What I sell is not a recording of the piece but a system that generates the piece. And, of course, the system generates the piece endlessly and differently all the time. Since the rules aren't deterministic, it means that

every version of it is going to be slightly different. . . . We've had a hundred years of reproduced music: the record. And before that, ten thousand years of music which wasn't reproduced, where every performance was unique. This sort of completes that loop. . . . What I'm interested in is the computer as a generator, not as a re-producer."

I downloaded "Orgina 2"'s rules over the Web and then launched the software scripts using the Koan music system on my computer. Soothing textures emanated from my speakers. Long, sustained tones. Gently shifting harmonies. I let the computer play its music in the background like the aural equivalent of a screen saver. For hours.

Keep in mind that a computer's processor is constantly running (assuming it's plugged in!). If you haven't given it anything else to do, it idles, following a program loop that instructs it to wait until its next command: "If no one touches an input device, wait until they do. If no one touches an input device, wait until they do. If no one touches an input device, wait until they do." While it's waiting, it can just as easily follow instructions to compose and perform some music: "If no one touches an input device, compose and play some music. If no one touches an input device, compose and play some music."

As I listened to the drifting harmonies, I had little doubt that this was a much better use of idle computing cycles. The rules defined a "field" within which the computer spontaneously created different sound textures until I instructed it to do otherwise. My computer exhaustively explored the possibilities of Eno's set of composition rules. I left it to perform hours of original improvisation. The textures became part of my environment. In fact, when I finally turned it off, I had the sense that something special was missing.

A NEW WORLD ORDER

Virtual worlds generated by computers use fractals and the rules of artificial life to synthesize a universe of seemingly infinite richness

to explore. Sims's waterfalls combined with Truax's water textures suggest the possibilities of rich sensory worlds. Even more intriguing, Reynolds's and Sims's works point to future worlds populated with autonomous and intelligent artificial life-forms. Meanwhile, extrapolating from Sims's godlike control of the genetic mix, or the interactive controls of Rundgren's *New World Order* and the Koan system used by Eno, it's possible to envisage worlds in which you'll be at the controls, with the power to influence the shape the world takes: the lifelike forms, the sounds of these lifelike forms, and the virtual environment they inhabit.

Imagine that you step into a digital world and become part of it—literally. The computer is the intermediary. It connects you—your actions, your responses, your commands—with the designer's bounded experience. You can act and interact with the environment and others, including digital actors that respond to you and what you do. The traditional distinction between observer and observed dissolves. Through your actions, you "interpret" the artist's world in a way that's very different from an experience of a static sculpture or painting. *You* shape the experience, perhaps in a way that the artist never envisioned.

You explore an entirely different dimension of digital discontinuity. You're at the controls, traveling through a "field" of experience. You follow different paths within a range of possibilities. Setting the parameters, you navigate between rigid control and total chaos. Program scripts fly through cyberspace, creating sound textures and animating the forms that respond to you and the moment.

Keep in mind, these digital worlds are not bound by the laws of the real world. All bets are off. Anything can happen.

5

GhostDance

In an experimental multimedia project led by Mark Podlaseck at IBM in 1995–96, the world-renowned composer Philip Glass collaborated with set designer Robert Israel to create a radical new form of musical experience for the World Wide Web. Although never completed, the prototype integrates many of the qualities of the wired worlds, virtual worlds, software worlds, and animated worlds I've described so far. Mark Podlaseck had read my book *Digital Mantras,* which provided a foundation for the design approach to their project. In addition, I was an adviser to the project, helping to evaluate the technological challenges. The following scenario seeks to capture the experience of a first-time observer, just as if I were seeing all the parts of an opera brought together for its premiere. It describes one of an infinite number of possible experiences in the rich interactive digital world we envisaged—a world where groups of Internet-connected participants gather in virtual space to share what we call *GhostDance.*

The first Ghost Dance was created by the Plains Indians in the 1870s, when they were poised on the brink of extinction. White Man, a Paiute Indian, communed with the spirits. He shared his visions with others in a ritual dance to raise the dead and drive the white men from their land. His dance spread from tribe to tribe—

to the Apache, Arapaho, Cheyenne, Crow, Kickapoo, Kiowa, Ojibwa, Potawatomi, Sak-and-Fox, Shoshone, Sioux, Walapai, and Winnebago—even as white men invaded their lands, killed their buffalo, and massacred their people.

The dancers formed a hub with eight radial lines. They danced around either a fire or a sacred bow and arrow placed in the center of a circle. Each tribe adapted the dance to suit its own customs. For example, the men and women of the Sioux danced naked in concentric circles, holding on to the diagonal ends of a handkerchief so their hands would not touch.

Through the ritual, the dancers entered a trance and a shared dream—a consensual hallucination. The world, and white men with it, was swallowed up in a great earthquake and consumed in a ball of flames. After three days, the Indians faithful to the Great Spirit were resurrected. In the wake of the destruction, the Ghost Dance was a dance to reconstruct their lost society from their collective memory. It conjured up the lost great buffalo herds, the ghosts of the dead, and the great departed warriors and their chiefs and restored them to a virgin world. Each of the dancers carried a magic feather to transport them to that new world when it came.

FIRST MOVEMENT: TRANSFORMER

When I arrive at the Web site of *GhostDance,* I'm blinded by jagged-edged static. Purple tones dominate. I hear the soft hiss of white noise.

I look around and see a bright blue-shaded cluster of unresolved pixels in the distance. Using a joystick for navigation, I pilot toward the cluster. The purple mist begins to dissipate. Blue skies thick with twisted pink, orange, purple, and red strips of fractal clouds emerge from the visual noise. As I fly toward the amorphous multicolored soup, I see cubes suspended in what is now an expansive skyscape. Each cube is the avatar of a visitor to this virtual world— logged on from New York, Rome, or maybe next door.

Some hypercubes float across the sky like balloons. Others are visible only by the trace of their trails. Their sides reflect the skies,

mirrorlike; I fly toward another avatar and see the approaching hypercube that is my own reflection. The cubes are collecting in the middle of a stunning, fiery sunset. From the intense spectrum of colors, I know it's sunset on an alien world.

At the same time as the electronic mist disperses, a deep sound distinguishes itself from the white noise. It resonates like the hum of a jet engine heard through the sonic debris in the flight cabin— it's still noise, but it's shaped by a distinct timbral quality. Then I realize that the sound is following me. It's *coming* from me. I hum. It's my sonic footprint in this virtual space. In fact, the other avatars also broadcast distinctive audible signatures. There are now sounds all around me. The drifting cubes' sonic identities are characterized as unique bands of filtered noise.

I'm being pulled gently toward the center of the cluster of cubes. For a moment I'm afraid of colliding with another avatar. Then I relax. I realize that my position is constantly corrected so I don't get

too close to the cubes in front, behind, or to my side. A Reynolds-like flocking algorithm coordinates our movements.

As my cube and the others are drawn into flock formation, the sound of each avatar becomes more focused. Rather than a band of noise, each cube now emits a definite pitch and timbre. The noises have subtly been transformed into pitched drones. One cube resonates like a bowed violin. Another softly sings with the voice quality of a soprano. My hypercube booms with the brassy richness of an electric bass saxophone. As we settle into formation, the tones of the flock mesh to create a simple harmony.

Other flocks also hum their chords in the open skies. The air fills with the sustained drones of avatars flying in harmonic formations, the sound signature of each flock determined by its size and shape. The flocks and harmonies drift unconnected. Chord fragments appear and disappear.

The sound and visual progression unfold in parallel. The visual noise transforms into blue skies while the aural static is displaced by resonant harmonies. All the while, an invisible force—some unknown gravitational attractor—draws us forward. The different flocks begin to merge. A long line forms, extending into the open color-space. As the loudness increases, the musical flocking algorithm links up the flocks to form a unified harmony.

I think to myself that it's as if I'm part of an audience arriving for a concert, filing into the performance space. The assembling audience is accompanied by the echolike prelude of an orchestra tuning up before the show. In the end, all the instruments play the same note. In tune, they're ready to perform. But rather than entering an ordinary theater, I'm coasting through virtual space, guided by a subtle gravitational force. We're being sucked into a black hole folded into the brilliant sky. The air is filled with the crescendo of sustained harmonies as the string of cubes disappears into the collapsed star. Then the darkness envelops me. I wonder: Is this the doorway to the virtual theater?

SECOND MOVEMENT: MATRIX

I'm disoriented by the discontinuity. After a moment, I look around and regain my bearings. What I see certainly isn't like any ordinary theatrical stage!

I'm inside a massive cube of regularly spaced shining gray bars. In front of me there's an open space filled with what looks like drifting debris. Flat-screen TVs broadcast a Bogart movie, a Disney cartoon, and an IBM commercial. A row of Muybridge images hangs like translucent wallpaper.

I hear the voice of a barker: "Step right up. Define your identity. Pick up twelve vestiges of our culture that will tell us something about who you are." The digital actor points me to the rows of neon-colored merchant stalls. Like the concession stands at a stadium event, they offer high-tech collectibles—everything from GIF-files and Java-applets to discounted virtual RAM. If virtual reality has a Times Square, I've found it.

I use a mouselike device like a virtual finger to touch items at stalls in the bazaar. The indicated objects are programmed to fly off the stalls at once and magically attach themselves to one of my hypercube's panels. I select an image of William Burroughs for one panel and one of Jimi Hendrix for another. Inside and out, I accu-

mulate artifacts and icons that, in effect, define my hypercube's identity. I'm now ready to make my way through the matrix of our cultural memories.

I hear the pulse of a drum beating in the distance, *ta-ta-ta ta-ta-ta*. I look in the direction of the sound and see the flock of cubes, still in line formation. Using my joystick controls, I navigate my avatar and rejoin the flock, but now we're flying through a gridlike structure. I see that the other avatars have also collected "identities." As we penetrate the matrix, the hypercubes reflect the glow of a soft pastel-blue light shining from the structure's interior.

When I pass between a pair of bars in the grid structure, my sustained deep saxlike tone sounds as if it's been injected by a burst of air: *baaauuuummmmmmmm*. It quickly returns to a sustained drone. As I pass the next pair of bars, there's another attack: *baaauunummmmmmmmm*.

My saxlike voice develops a slow, deep bass beat as my hyper-cube takes on a rhythmic musical identity. The beat mirrors my movements through the grid structure. Long sustained tones are triggered by each set of bars, almost as if an invisible barrier were spread taut across my path.

Coming from my neighbor in the flock is another rhythmic phrase with a violin timbre: *zeee zeee zee*. After a brief pause, my neighbor repeats the phrase: *zeee zeee zee*.

A third rhythmic phrase, voicelike, sings *pa-paa paa paa pa pa-paa paa paa pa*.

Other hypercubes can also be heard, separate from the background drone, each with a unique rhythmic identity, each out of phase with the others. The rhythm becomes increasingly complex. Each avatar is at the same time both a member of the orchestra and a member of the audience.

We're moving at a comfortable tempo, allegro moderato. It's neither fast nor slow. The grid bars slide by like telephone poles along a winding coastal railroad when you're riding at a leisurely forty

miles per hour. I think to myself that it's impossible to quantify speed by any absolute measure. This virtual world could be miles across. But it could just as easily be thought of as microscopic. I don't know if the avatar that represents me is of molecular or monumental scale.

Various cultural icons peer in at us from outside the matrix. General Custer looks on at the Ghost Dance that was born of the invasion he was part of. An image of Rimbaud recites a poem: "Jadis, si je me souviens bien . . ."—"In former times, if I remember rightly, my life was a feast at which all hearts opened up, at which all wines flowed. . . . Finding myself on the point of sounding my last *squawk!* I thought of searching for the key to the ancient feast." I look back and, for a moment, I think I see David Bowie in the reflection of a group of avatars.

Meanwhile, almost unnoticeably, the rhythms of the whole flock shift until everyone is in lockstep. The flock is now moving through the matrix at such a pace that it takes only a single beat to pass from one pair of grid-bar triggers to the next. The movements of all the avatars, their rhythmic phrases, and the beat of the passing grid bars synchronize. All the members of the flock now execute their rhythmic patterns completely in phase. The hypercubes pulse like a string of boxcars zipping down a railroad track: *ch-ch-ch-ch ch-ch-ch-ch ch-ch-ch-ch ch-ch-ch-ch.* The hypnotic rhythm induces an almost trancelike state: *ch-ch-ch-ch ch-ch-ch-ch . . .* Then, suddenly, I'm thrown from the luminescent grid structure. The music fades while my eyes adjust to the limited light.

THIRD MOVEMENT: THE GARDEN OF FORKING PATHS

I'm inside a massive pipe, sliding downward, floating through a dark cavernous space with the expanse of a Himalayan valley. It appears to be miles from one side of this ethereal conduit to the other.

The inner surface of this enormous tube is pockmarked with the

texture of the moon. I'm still a little disoriented by the odd perspective. It's like being inside a hollow, tubular moon.

I look behind me and see that the grid structure is insulated within a protective sphere suspended in the empty space. It recedes rapidly, like a satellite disappearing into the void.

Meanwhile, my cube has unfolded. With a surface that now appears to be made from a black crepe-textured foil, I'm like a shimmering metallic bat flying by sonar through this unearthly cave. The twelve ancestral portraits and landscapes that are my identity color my sides like dabs of electronic war paint. Once again, my avatar sounds a long sustained drone.

I'm stunned by the sight of a glistening cone and floating sphere profiled against a bright reflective mat. As I arrive at the base of the conical form, I look up in awe. The space has the grandeur of an ancient pyramid rising from the desert sand. A pure geometric monument placed in the middle of the vast expanse of space. It's simply there. But rather than think of the sweat of slaves toiling to put massive blocks of stone in place, I try to imagine the massive computational engines in the network of servers working feverishly to determine the precise position of every avatar.

My avatar repeats a slow, short melodic phrase. With melody, the music develops a new dimension. The violinlike hypercube plays a fragment of a scale, up and down, over and over. My deep bass line anchors the music as more and more melodic phrases surround me.

A sign indicates that I'm entering the Garden of Forking Paths as a voice reads Borges's story:

> . . . a labyrinth of labyrinths . . . one sinuous spreading labyrinth that would encompass the past and the future and in some way involve the stars . . . The Garden of Forking Paths is an enormous riddle, or parable, whose theme is time. . . . Each time a man is confronted with several alternatives, he chooses one and eliminates the others. . . . *He creates,* in this way, diverse futures, diverse times which themselves also proliferate and fork . . . an infinite series of times, in a growing, dizzying net of divergent, convergent and parallel times. This network of times . . . embraces *all* possibilities of time. . . . Time forks perpetually toward innumerable futures.

Trace lines etched in the ethereal air present me with multiple paths. I push on my joystick and veer to the left. My bass-line melody is slightly transformed. After a few twists and turns, I switch to another track with a quick jolt to my controls. My melody changes again. It's as if I'm driving a race car through a series of unending cloverleaf mazes on an L.A. freeway. But with each branching decision, I'm exploring alternative riffs in a musical improvisation. It's a *musical* labyrinth. The musical textures are the result of my choices as well as the choices of the other avatars.

The swarms of hypercubes interact to create a startling counterpoint resembling the melodic textures of Glass's "Photographer." I try to deconstruct the composing algorithms that create this symphonic counterpoint. I imagine them hurriedly creating scripts of performance instructions that are transmitted across the network.

After several rotations around the cone and sphere, I pick what

appears to be an exit. The harmonies of the music change as I fly toward and straight through the radiant mat. I'm hurtling into empty space. As I accelerate, the lunar walls that surround me become invisible; the light from behind is completely extinguished. In total darkness, I don't know if I'm moving or motionless. I have a fleeting sense of claustrophobia. It's silent. . . .

FOURTH MOVEMENT: THE FLOW

After seconds that might have been hours, a bright ball of light is visible. My sides have refolded into a starlike configuration. I'm now part of a flock of brilliant red foil-skinned abstract forms, a column that disappears behind me and stretches before me as far as I can see.

Columns of green, yellow, and blue forms also emerge from different points in the darkness—one from above, another off to the right, a third from below. The columns converge in concentric circles to form a multicolored thread that wraps around a fiery sun.

The interlocking rings create a landscape from hypercubes that have completed a journey through *GhostDance*. The avatars merge into the Flow and are engulfed by the topology. *GhostDance* grows through the accumulation of every participant's experiences.

I wonder, what is this a Ghost Dance for? For a moment, surrounded by the debris in the Matrix, I thought that perhaps, like the original Ghost Dances of the nineteenth century, it was a lamentation for a lost culture. But as I look at the multicolored stream, I know that *GhostDance* is a celebration. We share a dream as our avatars, like virtual feathers, transport us to a new world.

Suddenly, I am jolted as if by a tidal wave as all the avatars loudly play the same melody in perfect synchrony. As the performance comes to a climactic conclusion, the individual avatars are absorbed inside some kind of network consciousness. An electric current flows across the interwoven bands that connect us like the Web itself. Our timbres, transformed to bright brass, shine brilliantly like the reflections off the thousands of avatars. Blinded by the shimmering light, I'm overwhelmed by the immense wall of sound. . . .

After a period of time—entranced by the whirlwind of sounds and images, I'm not sure how long; my sense of time is as off-balance as my sense of scale—I return from a meditative calm. . . . Whoa! I breathe in. . . . I breathe out. . . . I log off the Internet feeling I've been immersed in a world that is out of this world.

CREDITS

Music Design:	Philip Glass
Sound Design:	Kurt Munkacsi
Environment Design:	Robert Israel
Digital Art:	Bill Victor
Concept & Strategies:	Mark Podlaseck
Creative Direction:	Hal Siegel
Project Adviser:	Steven Holtzman

PART II
THE MEDIUM IS THE MESSAGE

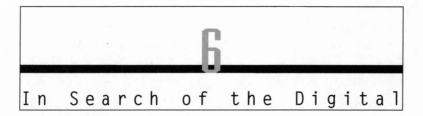

In Search of the Digital

Lᴵᴷᴇ any other medium, digital media have qualities that make them uniquely suited to express certain ideas. Just as the qualities of stone and steel are reflected in the structures created by sculptors, and the qualities of a guitar are reflected in music written for guitar, the qualities of digital media are reflected in digital worlds. These special qualities, new and unique to digital worlds, shape our experience of those worlds—their character, their philosophy of design, their "aesthetic." By isolating, understanding, and appreciating these qualities, we will develop a new aesthetic: a digital aesthetic.

IN SEARCH OF FLATNESS

What are the qualities that define digital worlds? The digital worlds visited in Part I are only glimpses of what's still to come. The Web is at the nickelodeon stage, while today's virtual worlds will be eclipsed as "reality builders" become more comfortable with the technology of VR and are freed to explore the essence of this new digital medium. Today's Web pages, CD-ROMs, and virtual worlds will soon seem as primitive and distant as black-and-white silent films.

Meanwhile, digital technology continues to change with bewil-

119

dering rapidity. A constant stream of new enabling technologies promises to open fresh possibilities. In particular, the Web—with the recent flow of technological innovations such as Java, Shockwave, VRML, and audio, video, and portable document formats— is a barely explored platform still in rapid flux. As we transform our world and ourselves with digital technology, we in turn modify the technology and constantly push forward the state of the art in an endless cycle. As we integrate each new form it becomes the old and we must again redefine the medium in terms of what is *now* "new."

In spite of all this dizzying change, from what we see today we can extract some of the properties that define digital worlds, and thus form the foundation for a digital aesthetic. We're sometimes inclined to think that the challenge we face today has never been faced before. But this isn't the first time we've struggled to understand and master a new vehicle of communication. Painters, writers, musicians, sculptors, and others have asked what makes a medium unique. Their experiences can help us in our efforts to understand digital media. Digital expression is, after all, part of the ever evolving continuum of human expression.

In particular, I find inspiration in the work of the seminal artists, writers, and thinkers who laid the foundation of our postmodern world. In the late 1950s, Frank Stella reduced painting to its fundamental qualities to try to understand what makes painting special, just as we might analyze digital media to understand what makes digital vehicles of expression special. The French philosopher Jacques Derrida explores how the limits of language ultimately shape what we say. His philosophy of deconstruction provides a framework for understanding how the limits of digital technology shape our digital expression. In his visionary writing, William Burroughs captured the nonlinearity that is a fundamental property of digital media. He demonstrates the cohesion that is possible in a nonlinear experience and sets a standard for new digital worlds.

Marshall McLuhan analyzed how human technologies become extensions of the human organism and the central nervous system.

Although he wrote primarily about "electronic" mass media, such as radio and TV, many of his ideas apply to the digital revolution. That's why he, more than anyone else, is the "patron saint" of the digital community.

In the midst of a discussion of things digital, the references to these predigital innovators may seem as out-of-place as a Burroughs cutout: all of a sudden, there's a discontinuity as one flow of text is abruptly juxtaposed against another seemingly unconnected context.

In December 1959 a virtually unknown painter named Frank Stella, twenty-three at the time, was invited to exhibit at New York's Museum of Modern Art. He presented four huge canvases bearing a pattern of stripes, painted in black enamel on raw cotton duck canvas with a flat two-and-a-half-inch-wide housepainter's brush.

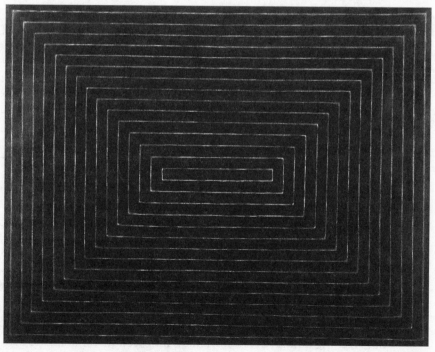

The contrast to the exuberant expressionism that dominated New York art at the time was striking. The emptiness of Stella's paintings appeared to be a total retreat from humanistic concerns. Although controversial, his work was critical in advancing the understanding of painting's formal properties.

Stella wanted to expose what defined painting as an art form distinct from any other. With that end in mind, he stripped painting of every quality that wasn't unique to it. He concluded that flatness alone was unique to painting. Its two-dimensionality was shared by no other art. He reduced painting to its essential qualities: flatness and the delimitation of flatness.

At the same time, he broke with old notions of painting. The lines didn't mark contours or create forms. The traditional distinction between figure and ground was obliterated; no part of the painting dominated. Stella rejected the goal of European geometric abstract art, which was to establish a balance among the parts. Unlike the abstract expressionists' work, Stella's monochrome canvases had no metaphysical meaning. He simply stated, "You see what you see."

Stella's work had a tremendous impact on his generation of artists. His Black Canvases captured the spirit of a new aesthetic. In a classic work of art criticism written in 1961, Clement Greenberg explained: "What had to be exhibited and made explicit was that which was unique and irreducible not only in art in general but also in each particular art. . . . It quickly emerged that the unique and proper area of competence of each art coincided with all that was unique to the nature of its medium."

For a moment, with Stella's Black Canvases, painting was stripped bare to reveal the essence of that art. And it was, in historical terms, a mere moment. But it was the moment in which the many new threads that characterize our postmodern world were first spun.

Rather than representing the end of painting, Stella's Black Canvases became the departure point for new approaches to art. Once painting had been laid bare, there was a tabula rasa to build on. Painting quickly evolved from Stella's ascetic minimalism, blos-

soming in the sixties and seventies into a wide variety of new schools.

I believe that, far from being out of place, the work of these predigital innovators provides insights for understanding digital worlds.

Specifically, I suggest that—as Stella did with painting—we first strip digital media to their essential qualities to isolate the characteristics that define what is digital.

ART IN THE AGE OF DIGITAL REPRODUCTION

Peeling the layers of structure from the surface of any digital world ultimately reveals the lowest level of abstraction in digital form: bits, 0s and 1s. A digital world's smallest element is the bit. Nicholas Negroponte of MIT offers an excellent description of a bit: "A bit has no color, size, or weight, and it can travel at the speed of light. It is the smallest atomic element in the DNA of information. It is a state of being: on or off, true or false, up or down, in or out, black or white. For practical purposes we consider a bit to be either a 1 or a 0."

In any digital medium, whether or not we're conscious of it, we're experiencing worlds that, in essence, are abstract structures of bits. The qualities of bits shape every digital world.

For example, a fundamental property of a bit is that it can be copied without loss of quality. A copy is as good as the original. In the digital domain, a copy is always perfect.

In the predigital world, a copy was always inferior to the original. The bane of the analog world was that each copy was a "generation" from the original, and each generation introduced some loss of quality. For example, making a copy of an analog recording of music requires replicating the electrical pulses that represent the waves of sound. Even the best analog technology could make only an approximate duplicate of the original. Every copy in the predigital world was in some way a compromise of the original work.

To make a copy of something digital, all you have to do is cor-

rectly copy a series of numbers and you have the perfect imitation. Tens, thousands, even millions of copies can be made without any loss of quality. *Every* copy is indistinguishable from the original.

The dawn of the twentieth century ushered in what is known as a modern aesthetic. While encompassing a multitude of positions, modernism revered high Art, with a capital "A." Modernists exalted the uniqueness and rarity of great works of art. The irreproducible brushstrokes of masterpieces were the foundation of their value.

In the 1960s, a few years after Stella's Black Canvases, Andy Warhol embraced mass media and popular culture to invent "pop art." Perhaps more than any other artist, he embodies the spirit of postmodernism. He was the first artist to create something radically different from high art for the edification of a few. He and other artists, such as Roy Lichtenstein and Robert Rauschenberg, who followed his lead, liquidated the barrier between serious art and mass culture.

Warhol's art mirrors the attitude of mass media. His paintings reflect a sense of detachment, taking a spectator's perspective, as if viewing the world filtered through a TV. Disjointed images—Campbell's soup cans, Elvises, Lizzes, and Marilyns—stutter across the screen.

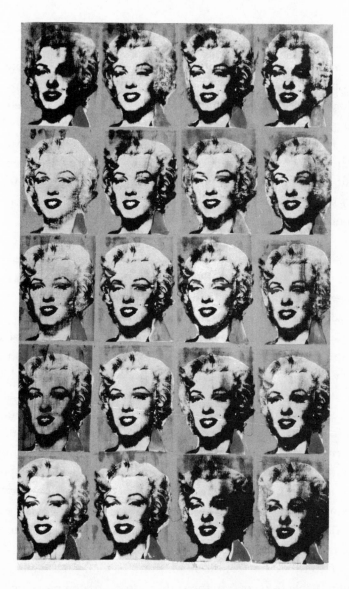

Warhol's work exploits mass media and mass production. The themes of his art are the larger-than-life images the media create of the stars of the media. The more the stars are copied, the greater their value. An image of Marilyn Monroe, patched like the sheet of stamps issued by the U.S. Postal Service in 1995, parodies the

Madonna icon of Warhol's Catholic childhood as well as the adulation of media stars by a secular culture.

Warhol emphasized photography's identity as a reproducible mass medium by using only already existing popular imagery. He made silk screens from photos, usually Polaroids, and washed out the resolution by reducing an image to a set of black and white dots. This gave his images the banal quality of tabloid newsprint. He then printed the images over gaudy backgrounds featuring the bright colors of TV. Using assembly-line procedures, Warhol's famous studio—called The Factory—manufactured a stream of products made of images from the American mediascape.

Digital worlds are the supreme vehicle of postmodern expression. What we all learn very quickly after our first introduction to computers is that copies of all sorts of materials can be made, contrasted, combined, and juxtaposed. In the digital world, we cut, copy, and paste with a few clicks of a mouse. In fact, it's easier to cut and paste an image or an audio or video sample than to create a new one. And with digital processes, copies can be modified, changed, and merged with other copied material.

The ability to "cut, copy, and paste" forms an aesthetic foundation for many of today's digital creations. Graphics designers use material distributed on CD-ROMs—"clip art," stock photos, graphic images—as source material to be modified and juxtaposed to create "original" work. The Web offers the opportunity to cut, copy, and paste from a worldwide repository of existing images and material. Netscape's Navigator Gold lets you create your own Web page by simply pointing to material on other Web sites and "dragging" it to where you want it on *your* own page. Even though it may be impossible to recognize the source after it's been processed, filtered, recycled, and recontextualized, nonetheless this creative process revels in a postmodern aesthetic.

Similarly, digital processing of existing material is an integral part of new musical styles such as hip-hop (although hip-hop began with nondigital "scratch" techniques). "Sampling"—reusing snippets of existing sound material—is at the core of a new musical

aesthetic. Whether recognizable references are parodic or reverential, they draw on the world of associations created by mass media.

The hyperlinks of the World Wide Web also are, in essence, vehicles for combining and juxtaposing material on a global scale. The associative hyperlinks among all kinds of disparate material reflect a postmodern combinatory quality.

The Web itself is built on the assumption that a digital copy is as good as the original. Digital copies of the content of Web sites are transported across global information networks without loss of quality. The images you view from the Web on your computer are exactly the same as the originals. Because of the unique property of a bit, there are in effect no qualities to preserve other than the order of the 0s and 1s.

Traditional values no longer apply. What is an original and what is a forgery in an age of perfect digital reproduction? How can we determine the authenticity of an image that can be assembled from any number of sources, tampered with without leaving any detectable trace, and copied repeatedly with no loss of quality? The notion of copyright is itself broadly challenged in a digital environment where there is no defense against copying bits and there is often no trail from the copier to the source. An economics based on rarity is turned upside-down. In contrast to irreproducible brushstrokes, bits gain value as they are used over and over again. Digital information is a commodity that gains in value the more it can be resold. Similarly, the value of a Web site increases the more it is referred to and the greater the number of visits and copies made.

DIGITAL AESTHETICS

Yet, even if digital media embrace mass reproduction with their ability to make an infinite number of perfect copies, the essence of digital media is not perfect repeatability.

Digital worlds are discontinuous. They don't present a predetermined sequence from A to Z. Hyperlinked discontinuities present a garden of forking paths. The power of digital discontinuity is the

opportunity to follow a unique route that responds to your interests, your choices, and your decisions.

The digital experience is interactive, not passive. Digital worlds respond to you, pull you in, demand your participation. The unique creation that results is not simply a "work" produced by an artist held high on a pedestal, but the interaction between you and the possibilities defined by the artist.

Digital worlds are dynamic and alive. Software programs create a "field" of possibilities and an experience that is tailored to you and to the moment. It cannot be assumed that in a dynamically generated digital world any two people will experience the same thing. Two experiences created from a broad field of possibilities may bear little resemblance to each other. As in a jazz improvisation or the live performance of music, it's the uniqueness of each interpretation that is the essence of a digital aesthetic.

Other qualities beyond nonrepeatability also define digital worlds. Digital worlds are ethereal. There's no "there" there. No material substance lies behind your experience. Digital worlds are unbounded by the constraints of the physical world. They have infinite resolution. They shift the focus from the literary world's page to expression in three-dimensional space.

Digital worlds are ephemeral. The experience of a sequence of bits exists only for an instant. Even a seemingly static image is refreshed millions of times per second in a computer's memory. The persistence of a digital world is dependent on continuous computation. A digital engine fuels the existence of every digital world you see, hear, and experience.

The essence of software written in programming languages like Java on the Internet is also ephemeral. Designed to be downloaded across the Internet, these software "applets" execute and then disappear. Such software applications for the Internet reflect an aesthetic of impermanence.

Digital worlds form a web of community. They connect people from across the planet to form virtual communities. They dissolve the barriers of time and location, and in their place create ties of interest and, perhaps, even a new form of global consciousness.

Digital worlds are shaped by a new aesthetic that embraces these uniquely digital qualities. However, simply employing these qualities isn't in itself enough to ensure a powerful or enriching experience. But, from the brew of uniquely digital qualities, compelling digital expression will emerge as an epiphenomenon. The ingredients will suddenly mix in a way whose explosive impact is greater than anything apparent in the nature of the medium.

Can definitive examples of these compelling new digital worlds be identified? To date, we have had only fleeting glimpses of the possibilities of greatness. In any case, when a digital world crosses that threshold and becomes a striking expression is a subjective determination. The depth and beauty of any experience—digital or otherwise—is different for every individual. However, with digital worlds in particular, individuals will bring their unique perspective to bear as they never have with any other media. The nature of the discontinuity of an experience is the result of your decisions. There is an interaction between you and a digital world. Digital media connect you to others to create personal communications that become part of your life. You shape your experience. Digital worlds, involving you, directly reflect you.

DIGITAL EXPRESSIONISM

The essence of anything in the digital domain is its abstract representation in binary form. Digital worlds exist only in cyberspace. Their essence is the structure of the bits from which they are realized. Text, graphics, music, virtual worlds, software worlds—all are represented in the computer as structures in abstract terms. Even a realistic virtual world is merely a database of abstract relationships in a digital datasphere that is mapped to sense-stimulating electronics to make these abstractions seem real. In essence, all digital worlds are reduced to the same underlying abstraction of 1s and 0s. Within a computer, there's no difference between the bits that are used to create music, text on a screen, a virtual world, or any other digital structure. The concept of virtuality can be extended to all worlds that exist in cyberspace.

Having followed this reductionist logic to 0 and 1, I was led to consider how I might strip away the layers that hide the true nature of bits. In our efforts to make computers easier to use, we put a comfortable face on computers by applying familiar metaphors— virtual offices with desktops, file folders, and trash bins; graphics tools in the forms of airbrushes and spray cans. We focus our efforts on simulating the real world in the virtual. In music, we focus on the digital synthesis of the perfect human voice, piano, trumpet, and percussion.

To me, what's most interesting is not how well a computer can emulate our familiar world, but rather the entirely new territory that computers open for human expression—worlds of expression inconceivable prior to the invention of the computer. As a musician, I was intrigued by the idea of *directly* mapping digital structure to sound. What sort of sound would it be? What does a computer generating a digital world sound like?

There was only one way to find out. I connected wires from the central processor of a powerful computer serving hundreds of users to an amplifier and speakers, and I listened to the sound of the computer in operation, processing bits, generating digital worlds. The sound represented a direct mapping of the state of the machine microsecond by microsecond—in the tradition, I thought, of the expressionist aesthetic.

In the early years of this century, the expressionist movement aimed to capture, in art, music, and poetry, the direct reflections of troubled inner psychological states. The composer Arnold Schoenberg represented the height of expressionism in music—his monodrama *Erwartung* in 1909 captured the spirit of his words "Art is the cry of distress uttered by those who experience at first hand the fate of mankind."

In the visual arts, the expressionists rejected the realism of the mainstream of their time. Edvard Munch's hallucinatory images, such as his *Scream,* directly captured his private miseries and epitomized the expressionist ethic.

The sound created by mapping the binary processes of the computer to speakers was unlike anything I had heard before. It was a completely digital sound—the sound of the computer's basic operations: store, retrieve, add, AND, XOR, logical shift.

It isn't a sound that can be described in terms of frequency or harmony or any other way of describing sound that preexisted the

131

computer. It's describable only in terms of the machine instructions that were themselves conceived as part of the invention of the computer's architecture. And it's a sound unimaginable prior to the invention of the computer, because it *is* the sound of a computer. It reflects the nuances and subtleties of my "digital instrument." The same operations executed on another computer will sound different. This computer's particular architecture—its particular set of basic machine operations, its implementation of multiplication, its "word" size, its processing speed—shapes the sound.

And the sound generated captures the moment. The interaction of hundreds of users in the form of thousands of processes executed in a sequence of millions of computations per second will never be repeated again.

Not surprisingly, it's a sound that is unmistakably digital: rich textures of completely unfiltered noise; intense concentrations of dense harmonic spectrums. It exudes raw power. It's music to *my* ears. I had found an entirely new *digital* sound, rivaling the wail of an electric guitar!

7

Sculpting 0s and 1s

SCULPTORS are taught to respect the material they work with. If the material is clay, the sculpture should look as though it's made of clay. If the material is stone, the sculpture should have the density of stone. If it's steel, then the finished work should reflect the strength of steel. Sculptors are taught to take into consideration how light, heat, cold, and the environment interact with the material from which they create. Sculptors must "know" the material they work with so they can unleash its expressive potential. The sculptor Henry Moore wrote, "Every material has its own individual qualities. It is only when the sculptor works direct, when there is an active relationship with his material, that the material can take its part in the shaping of an idea."

The grandeur of Michelangelo's sculptures reflects the color and scale of his massive blocks of marble. Rodin's sculptures emerge from slabs of rough unpolished stone, harnessing the raw power of their weight and immobility. More recent sculptors like Richard Serra slice through open space with massive sheets of steel; exposed to the air, the surfaces are covered in thick rust.

The artists of the future must also take into consideration the material they work with, sculpting the materials from which digital worlds are made.

CHAMELEONS OF THE JULIA SET

To better understand the relationship between a digital medium of expression and the creative process, I visited J. Michael James at his studio in the rolling hills of Sunol in northern California. James has dedicated himself exclusively to exploring the creation of his structures in virtual space. He wants to understand the possibilities for his art in a world where his material is nothing more than the computer-constructs of virtual space. I asked why, given his training as a traditional sculptor, he chose to work in a virtual medium. He replied: "My drive for self-expression requires digital media. I have a fascination with fractal structures. All sorts of fractal forms fly around inside of my head all the time. Yet, even though nature creates fractal forms, there's no way outside of the virtual for me to work with them for personal self-expression. I can't actualize my ideas in any other medium."

He paused, and I noticed that the view out the window—a red-tailed hawk circling above the dry brown grasses and craggy oak trees—was a stark contrast to the interior of his studio, cluttered with technology. James continued, "But it's more than that. It's not just that digital media allow me to express things I couldn't otherwise express. It's also that, as an artist, you're drawn to the media that are important. Today it's digital. Digital media are of our time. Digital media are what you *have* to use today. That's the point. In fact, it's always been the point. Warhol painted with popular images—they were the media of his time. He wanted to express something about what he saw around him, and he used the tools and techniques of his time. It's also what drives me to express myself in the form of virtual sculpture."

James creates his virtual sculptures on a network of Intel Pentium computers. The covers of the machines have been removed and placed in a stack to one side. The computers' exposed guts facilitate the removal and insertion of various components—James constantly adds faster graphics cards, bigger disk drives, more RAM, and new motherboards with upgrades to the latest processor in his futile attempts to meet the demands of his virtual art. A tan-

gle of cables connects graphics tablets, scanners, joysticks, and other devices to his computers. Yet James's studio isn't so much what I see scattered across the room, but, rather, what's within the computers—in cyberspace.

I peer through the portal to his virtual studio, a twenty-one-inch color-correct monitor, and see his *Chameleons of the Julia Set*. Iridescent chameleons hang from a wall in virtual space. I recognize that they're structured in the form of a fractal spiral known as the Julia set.

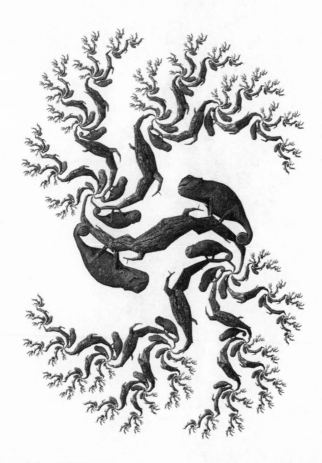

As I push the joystick and shift to a view from the side, the three-dimensionality of James's virtual sculpture becomes evident. The chameleon-vine clings like ivy to the polished white sheet of wall.

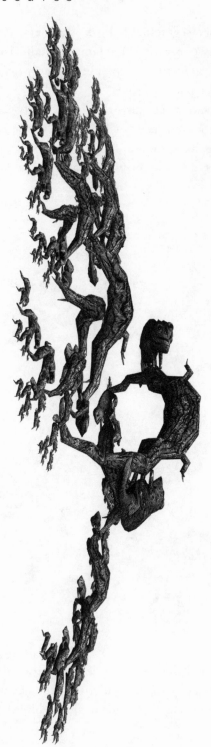

THE DIGITAL DESIGN OF A CHAMELEON

Rather than using a hammer and chisel, James shapes his chameleons using software tools for digital design. His tools include computer-aided-design software for creating three-dimensional forms, utilities for digitally scanning photographs and graphics, various "plug-in" modules for processing digital images, and programs that perform the complex calculations required to simulate even simple lighting effects. I watch as he peels back the texture-mapped veneer of his chameleons to reveal the "wireframe" that maps their contour. He grabs it with his virtual hand and flips it around to view the wireframe from its original perspective.

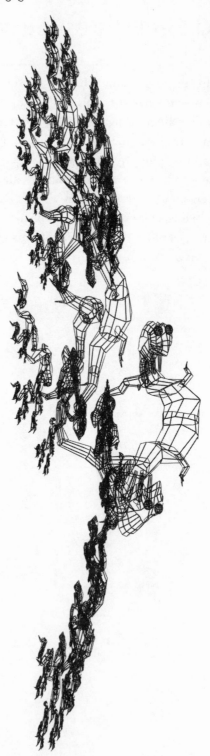

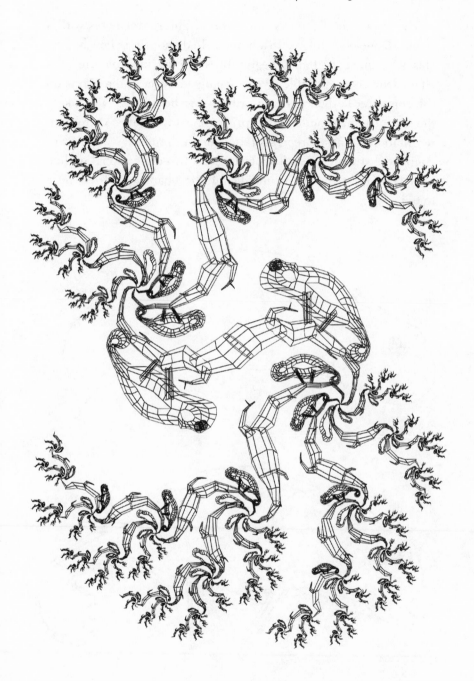

The structure of James's unnatural sculpture originates with a single chameleon clinging to a branch. To demonstrate how he creates a chameleon, James begins by scanning in a picture of a chameleon seen in profile. While typing a stream of directions on the computer keyboard, he describes what he's doing: "I'm taking the scanned image and digitally processing it to create a vector representation—that's a representation of the profile as a series of connected straight lines. This gives me a two-dimensional outline of a slice right down the middle of the chameleon from nose to tail."

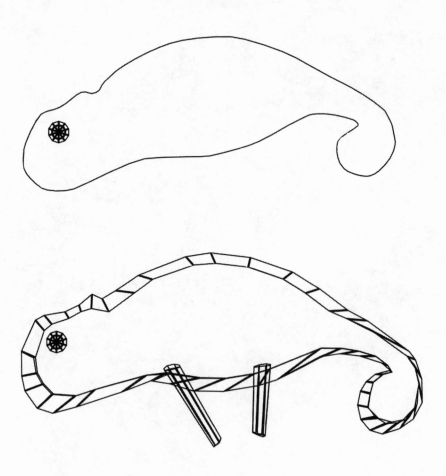

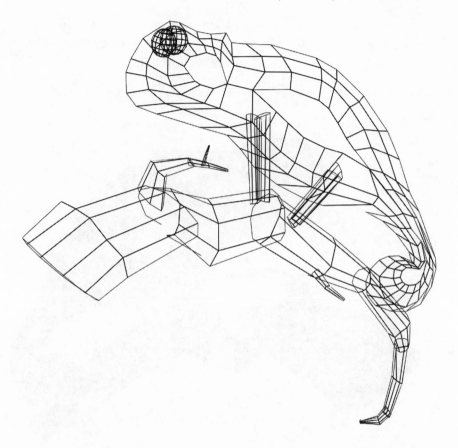

In order to create a three-dimensional form, James uses his mouse to make a copy of the profile. He then points to, clicks, and drags the connecting points of the vectors of this second outline to create another profile of the chameleon at a point halfway between the center and its side.

He continues by adding a third layer to the profile, halfway again between the second profile and the chameleon's side and, last, a fourth vector list describing the side itself to recreate the complete wireframe. It's increasingly obvious that the tools he works with aren't a traditional sculptor's chisel.

He again describes what he's doing: "After positioning the slices parallel to one another in layers, I instruct the computer to stretch

a virtual skin across the two-dimensional profiles. A transparent three-dimensional mesh forms a surface of connecting polygons. In total, each one of my chameleons is made of hundreds of polygons."

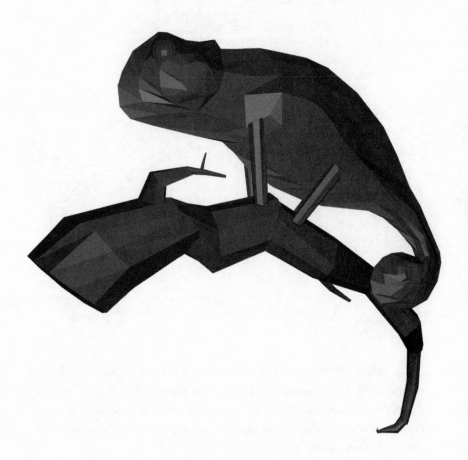

He continues to explain, "Within the computer, the wireframe itself is a data structure defined as a series of numbers that represent the vectors of its form." He switches from the graphical view of the chameleon that he has been manipulating to a textual view of the data to show me how the computer keeps track of the structures he's creating:

```
. . .
VERTEX
-238.767624 20 -234.272858 30 242.820145 70 192 0
VERTEX
-230.624588 20 -248.100037 30 246.640839 70 192 0
VERTEX
-230.777878 20 -262.700500 30 254.805893 70 192 0
VERTEX
-239.422287 20 -272.456177 30 264.313049 70 192 0
VERTEX
-251.660660 20 -271.826385 30 272.149475 70 192 0
VERTEX
-264.454071 20 -262.115295 30 275.486694 70 192 0
VERTEX
-269.094482 20 -247.592529 30 269.839233 70 192 0
VERTEX
-270.672424 20 -233.822052 30 262.358734 70 192 0
. . .
```

As he explains how "the computer processes the vector data lists to redraw the morphing forms," I realize that these indecipherable lines of computer code are the equivalent of the unpolished stone from which a Rodin sculpture ultimately takes shape.

Having created a three-dimensional wireframe model of his chameleon perched on a branch, James digitally scans photographs of the skin of a chameleon and the bark of a branch into the computer. He uses image-processing software to manipulate the hues and saturation of the chameleon skin's colors to give it an unnatural iridescence. He only slightly adjusts the contrast of the bark.

James then wraps the flat plane of digital surface onto the naked wire structure in a process known as texture mapping. James explains, "I've now created the digital representation of my kernel chameleon. I replicate this form to create the larger overall structure."

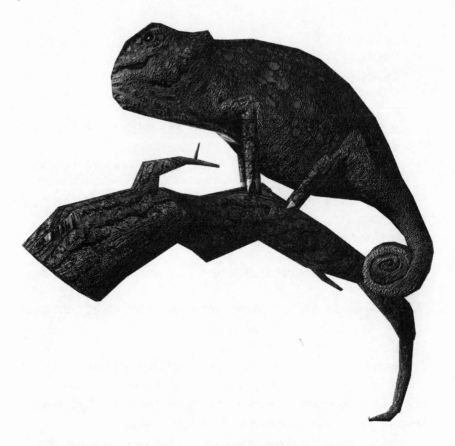

CREATING THE JULIA SET

To create the larger structure of his sculpture, James mirrors the chameleon image with a few simple instructions to his computer. He then applies the "quadratic iteration $z^2 + c$" to each of the two chameleons, and then to each resulting chameleon, again and again and again until there's only abstract form. Although I don't completely follow the mathematics of the "affine linear transformation" James applies to create the fractal Julia set, I do see the structure emerge as the computer displays the results of each step in its calculations.

The rendering of a single view takes hours of computation. Vector lists are processed for size and position. Flat textures are wrapped around wireframes. Lighting reflections are calculated,

taking perspective into account. The complex array of binary numbers that represent the texture-mapped surfaces is processed by a series of other computer instructions to "ray-trace" the reflected lighting. While we're waiting for the computer to complete its work, James explains that ray-tracing, a technique for achieving realistic lighting effects, "is a process of rendering light by following the path of individual light rays backward. If you turn on a light, it follows a path, bounces off things and gets to your eye. With ray-tracing, it starts with the perspective of the viewer, or the camera, and traces the light back to its source. It's incredibly computation-intensive."

After a few hours, the computer presents the results of its computation. As we study the virtual structure, rotating it, zooming in and out, I ask James what would be involved in making a minor change—perhaps shrinking the chameleon's width, or tweaking its skin tones. After confirming that I was only posing a hypothetical question, he smiles as he describes the flexibility of his virtual medium. "If this were, as they say, carved in stone, making changes would be a major production, especially if you wanted to restore a part that had already been cut away—that, of course, would be impossible. But the virtual material I'm now working with is incredibly malleable. In the end, my sculpture is made up only of a string of bits, each of which represents a dot of the image that creates the illusion of a virtual world."

He types a series of instructions to the computer to show me the internal binary representation of the sculpture within the computer. Like smooth polished marble seen through a microscope, hundreds of thousands of zeros and ones fly across the screen:

```
. . .001010100000000000000001000000011000000010
00100010000000100000100000110100000000100000
00100111101010000111001110000000000000000000
00000011110101010000001100101110000000011000
10111000000011110001000101000000000010101100
001010000 . . .
```

James then goes on to explain, "My sculpture is a unique structure of 0s and 1s. In its essence, it's only digital information. To

make a change, all I have to do is instruct the computer—in effect, reprogram it—to recompute the sequence of bits. It's when I make a mistake or want to make a change that it's most clear to me that creating virtual sculpture is nothing like working in stone or clay."

Sculpting in virtual space with his digital tools, James creates fractal worlds out of trout, chameleons, scarabs . . .

and condors . . .

VIRTUAL SUBSTANCE

Digital technology has made possible new media that cannot exist independently of it—media that exist exclusively in the digital domain. The virtual worlds of J. Michael James are one example.

A virtual world ultimately exists only as digital data that map to an analog format to evoke sensory experiences. At its foundation are the binary data that define its structure. Without the digital representation, there is nothing.

James's virtual sculptures exist only in cyberspace. He creates his works in a world that exists only in the digital domain. His material is not clay, marble, or steel in the physical world. It's the substance of cyberspace. He sculpts with an infinitely pliable material. He sculpts his worlds out of 0s and 1s.

8

Digital Limited Inc.

TODAY, in the early stages of digital technology's development, its limitations are *very* apparent. You can't sit in front of a computer without groaning about this or that deficiency—graphics resolution, processing power, memory, communications bandwidth, ease of use. And even as the technology progresses, and as fast as it may progress, limitations will always be present.

These limitations shape what is expressed in digital form. While expression in a digital medium may exploit the newfound freedom of nonlinear form or unbounded virtual space, digital expression nevertheless is constrained by other technological limitations.

This is true not only for digital media, but for all forms of expression. Jacques Derrida, for example, has examined how the limitations of written language determine what can or cannot be expressed in it. Derrida's philosophy of deconstruction is heady stuff. And it has attracted followers of nearly cultlike devotion. But if you're not an initiate, Derrida is hard to understand: like the doctrines of other cults, his writings are intentionally difficult to interpret. However, in Derrida's case, the intent isn't to be impenetrable to the uninitiated. Rather, his point is that it's impossible for him to truly communicate his ideas because the meaning of language itself is impenetrable.

Derrida explains in his book *Limited Inc.* that, ironically, it is in

the very ability of language to express ideas that we find why it's impossible to faithfully express ideas in written language. Specifically, Derrida suggests that the power and ultimate weakness of written language is its ability to record something at one time, to be interpreted at another: "A written sign carries with it a force that breaks with its context, that is, with the collectivity of presences organizing the moment of its inscription. This breaking force is not an accidental predicate but the very structure of the written text."

Another time means another context—a different context from the original one when something was first written down. Derrida explains that because the contexts that fix meaning—the viewpoint, the time, the place—are never stable, written language can never be completely understood by anyone other than the writer at the time he or she wrote it. The context is never the same for the writer and a reader; the two have different personal viewpoints as frames of reference, writing and reading the text at two distinct moments in time and probably in two different places. And if the context is different, then the way the text is interpreted will be different. In other words, in a different context the same thing means something else. It may be just a little different, or a lot. Nonetheless, it's different—and therein lies the undoing of written language.

The quality of "iterability" shapes the medium of the written word. Writing about a written note, Derrida clarifies: "These possible absences, which the note is precisely designed to make up for and which it therefore implies, leave their mark in the mark. They *remark* the mark in advance. *Curiously,* this *re*-mark constitutes *part* of the mark itself. And this remark is inseparable from the structure of iterability."

This passage demonstrates why Derrida's writing is notoriously difficult to understand. Any reader struggles to make sense of his texts. As he playfully twists the multiple meanings of words, you may read a paragraph once or twice and think about what he meant to say. This struggle is a key part of Derrida's communication of his point. In fact, the difficulty of understanding his point *is* his point:

the full intention of his rich associations can't be fully appreciated by *any* reader.

Derrida masterfully exploits the limitations of his medium—with its inability to communicate ideas clearly—to communicate his ideas. He has defined his aesthetic of writing in terms of the limitations of the written word. He exploits those limits as a strength, to express the idea that he cannot fully communicate his ideas using written language.

To the extent that a medium shapes a message, the medium's limitations set the boundaries of what can be expressed in it. And so the limitations of the digital medium define our experience of it.

The challenge is to use these limitations and turn weaknesses into strengths, to match the expression and the medium. The following examples illustrate how mastering expression in digital form involves exploiting the limitations of digital media.

THE PIXELATED IMAGE

Your interface with your computer is probably a color monitor. Your computer display, still the most common interface between human and machine, is a point of tremendous limitation. Compared to printed media such as a book, a computer display has a fraction of the resolution.

The information designer Edward Tufte describes this unfortunate bottleneck.

> Computer displays are low-resolution devices, working at extremely thin data densities, 1/10 to 1/1000 of a map or book page. This reflects the essential dilemma of a computer display: at every screen are two powerful information-processing capabilities, human and computer. Yet all communication between them must pass through the low-resolution, narrow-band video display terminal, which chokes off fast, precise, and complex communication.

The letters on this printed page appear smooth to your eye as you read them. But even the high resolution of an above-standard 1600-by-1200-pixel computer display is not enough to eliminate

the "jaggies" of a simple font such as the one on this page. The discrete nature of the pixel (a "picture element" or dot on your display screen) characterizes the display of information on a computer. Ultimately, any digital image resolves to dots on a display, even if at enormously high resolution. And even if the resolution renders the discrete edges of an image or character invisible to the eye, if you "zoom" in closer and magnify the image, you'll find it's composed of discrete and jaggy pixels.

However, embracing the constraints of the digital can define an aesthetic. The pixel can be placed on a pedestal and exalted as an icon for the digital world. For example, the discrete and unresolved quality of the pixel is captured in the corporate identity of the "new" Xerox—"The Document Company—Xerox"—for the digital age:

The exaggerated, pixelated typography expresses the "digital" and represents a design aesthetic that defines itself in terms of the limits of the technology. The discontinuous nature of digital technology, its fundamental limit, is exploited to communicate an idea—the idea of the "digital."

With the development of video, the blurry grill of a video image defined a new aesthetic in contrast to the high resolution of film. Similarly, the pixelated resolution of a digital image is championed broadly by graphic designers as part of a new "digital" design philosophy. It's now common to see pixelation used in nondigital media

to represent the digital world. It immediately conjures up the distinctive visual quality that makes digital images unique vehicles for expressing certain ideas.

THERE'S NO HAIR THERE

As we've seen, the virtual Metaverse of Neal Stephenson's *Snow Crash* is inhabited by "avatars," virtual incarnations of people. Just as the clothes you wear shed light on your personality, in Stephenson's sci-fi virtual world, your avatar is also revealing:

> Your avatar can look any way you want it to, up to the limitations of your equipment. If you're ugly, you can make your avatar beautiful. . . . [But] most hacker types don't go in for garish avatars, because they know that it takes a lot more sophistication to render a realistic human face than a talking penis. Kind of the way people who really know clothing can appreciate the fine details that separate a cheap gray wool suit from an expensive hand-tailored gray wool suit.

Even in the world of science fiction, the limitations of technology determine the structures and forms that can be built in virtual space.

In the real world of technology that builds virtual worlds, a realistic human face is a very complex image to synthesize. Probably the most difficult part to create today is hair.

A head of hair includes hundreds of thousands of individual hairs. To create hair's natural elasticity and sheen with a computer requires that *each* hair be represented by many small surfaces, and thus by a very very large number of edges. Within the computer, each hair is represented by a "wireframe model" of cylindrical structures, each of which in turn is made from a number of discrete edges. A head of hair is composed of *millions* of the tiny cylindrical structures.

To create a realistic head of hair demands enormous computer power or a lot of time for the rendering process. So if you're trying to replicate a person in an animation or a film, you fake the hair—

unless you have a budget that would dwarf Spielberg's for *Jurassic Park*. As a consequence, virtual hair looks like a plastic wig—like the hair of Woody, the toy cowboy, in the first feature-length computer-generated movie, *Toy Story*. There's a technological reason, as well as a story reason, why his hair is stiff as wood.

© Disney Enterprises, Inc.

Your first inclination may be to think what a clever idea it was to choose toys as a theme. Indeed it is, but the very choice reflected the underlying technology. Toys are synthetic and plastic and lend themselves to the synthetic and plastic look generated by today's computer graphics. Did you notice how out of place the "real" people seemed whenever they entered a scene? Inability to meet the demands of realistically simulating people produces unrealistic and seemingly out-of-place human characters, jarring in the context of the overall "toy" aesthetic.

You may have noticed that even in the most sophisticated computer-generated animations, many humanoid forms are bald. So ubiquitous is this concept that baldness has come to mean "futuristic." It's just that the designers didn't have the computer power to render hair. In fact, the limitations of the technology led to the futuristic aesthetic.

Eventually, we'll have enough computer power, and suddenly all the characters in virtual worlds will sprout hair. Until then, we'll have a *Snow Crash*–like Metaverse filled with low-cost "Brandys," avatars with facial features that match the elegance of mannequins: "Her eyelashes are half an inch long, and the software is so cheap that they are rendered as solid ebony chips. When a Brandy flutters her eyelashes, you can almost feel the breeze."

FLAT TEXTURES

Hair is not the only technological challenge facing the digital artist. To realistically recreate the pebbled surface of a road, for example, presents difficulties comparable to those of simulating hair.

Why not create the full texture of a road's pebble surface? To create a surface with real depth requires that, just like a real road's surface, the virtual road be built from many objects, many individual pebbles pushed together. But, again, this requires massive computer power.

A cheaper method in terms of computer power is to build a flat surface and then make it *look* as if it has a rich texture. You find a nice pebble road like the one you want, take a photograph of it, scan it into the computer, and then "map" it onto the flat surface where you want a pebbled texture. The process is known as texture mapping. (It's one of the techniques we saw J. Michael James use in Chapter 7.)

At a glance, it looks fine—after all, it's a photo of a real road surface. But don't look at it too carefully. The problem is that—just like a photograph—it's flat. There's no real depth. If you get too close you notice that the shadows don't vary with your movement;

there's no sense of light refraction from a higher point versus a lower point of view. The "road" is wallpaper.

Texture mapping gets the desired effect without demanding massive computer power, but its artificial look becomes apparent on close inspection. Because of the limits of today's technology, we can't yet find true natural surfaces built in cyberspace the way they're really built—out of lots of little objects and surfaces.

WHERE'S THE MIST IN *MYST*?

Natural lighting creates even more technical problems. Natural lighting is highly reflective and changes with atmospheric conditions. In fact, one of the main cues humans use for depth orientation is that the farther away an object is, the blurrier it is. Air is not clear; it includes particles that reflect light and that over any distance interfere with light. If you look at something two inches away, it's crystal clear. But something two miles away seems foggy.

Fog, refraction, reflection—all the things that occur in reality— are very expensive to render with a computer. As a result, digital artists have a tendency to make faraway things look just as crisp and clear as nearby things, only smaller. Everything is in focus. There's no depth of field. And digital artists have a tendency to use spotlights, which limit the computer power necessary to render a scene. Artificial clarity is one of the things you see that are due to the limitations of computer power.

Computer-graphics artists accept this unnatural look. They make objects recognizable, knowing that the objects won't look real. They even exploit the fact as part of their design aesthetic. In the crisp air of the best-selling CD-ROM *Myst*, images don't grow foggy or dim with distance. But the artificial crispness is also part of *Myst*'s otherworldliness.

Another design approach accepts that a symbolic tree represents "treeness." Such an approach exploits a look that is consciously developed as an artificial, rather than a literal, rendering of a tree— again, because the artists don't have the computer power. *SimCity* has a cartoonlike style that is perfect for this Lego-like build-it-yourself artificial world.

The aesthetics of today's virtual worlds are shaped by the limits of today's technology.

PLAYING SLEIGHT-OF-EYE

Two key limits define the quality of a *dynamic* virtual-world experience: the complexity of the world, as determined by the number of edges and textures displayed; and the response time, that is, the speed at which images and scenes are updated. *Myst* and *SimCity* render visual images in a static virtual world. In a virtual world where you can move and interact, the computer must render images fast enough to match your movements and provide a sense of interactivity. The limits of computer power are now subject to the limits of time.

The idea of virtual reality is to create the feeling of "being there." It's necessary to deliver an experience exactly like the one you'd have if you really were there. Our perception of spatial reality is driven by various visual cues, many of which are directly derived from movement. Fundamental to this is the expectation that, if you change your point of view, the image will change instantly to match.

As you move your virtual head, the computer must create a new picture. The illusion of continuity depends on the flashing by of twenty-five or thirty images per second, just as in television or film. Multiply each frame by the massive calculative demands of creating each still image and you'll understand why even the world's most sophisticated supercomputers are brought to their knees creating virtual worlds.

Instead of enabling a smooth transition from image to image, lag times and slow frame rates can create strobelike effects that don't even begin to seduce you into suspending your disbelief and may even create a sense of nausea. Jaggedy graphics are especially unsettling because the jagged lines don't necessarily move in the same direction as the object on which you're focused.

But today's video game designers have learned to embrace these constraints as the basis of their aesthetic. In the game *IndyCar*

Racing (1993), the cars move quickly. The images constantly change. But freeze any given image and you'll find a mess of pixelation. The walls of the racetrack and the grain of the road are so crude that they're difficult to recognize. The single image barely coheres.

The road looks completely artificial, with big pixels, low color depth, and plain surfaces, none of which seem natural. But given a sequence of rapidly changing images, your eye cannot make out the detail of any single frame, and the rush of frames forms an animation that creates the illusion of racing over a road within the walls of the track. Game designers understand the tradeoffs between the speed of changing the images and the resolution of the individual images. The aesthetic of interactive games defines the speed of change as more important than the resolution of the image.

Meanwhile, the technology for rendering images seems to advance relentlessly. The following image from *IndyCar Racing II*

(1996) was created using the then state-of-the-art "Rendition" chip for rendering images on a personal computer. With a chip optimized to focus the limited computer power available on the areas to which the eye is most sensitive, even the computer's graphics processor design reflects the game aesthetic.

With the images changing at a rapid pace, "texture mapping" photographic images creates a more realistic finish for the images, while "anti-aliasing" smooths over the discrete transitions between pixels by blurring the edges together. Even so, you won't confuse the game with the real experience.

SCRATCHING THE SURFACE OF CD-ROMS

In printed form, an encyclopedia delivers broad coverage of many topics. Alternatively, a single book on a specific subject can present

a very close look at that subject. The physical constraints of the printed medium make it difficult to do both except in a multivolume encyclopedia.

Meanwhile, although the CD-ROM rendering of an encyclopedia may include sounds, color images, and even full-motion video, today's CD-ROMs are characterized by a lack of breadth and a shallowness that are dictated by the medium.

A CD-ROM today holds 650 megabytes, nearly 5 billion bits, of information. New DVD-ROMs increase capacity nearly tenfold. This seems like a lot, when you consider that an issue of the *Wall Street Journal* includes approximately 10 million bits of information. But 5 billion bits, or even 50 billion bits, is not so large when you consider the demands of video. A CD-ROM can hold barely an hour of compressed video. As a result, CD-ROM titles use a lot of text, stills, and some sound, but only snippets of full-motion video.

Furthermore, the access times of today's CD-ROMs are slow. To accommodate both storage and speed constraints, CD-ROMs feature small video windows a few inches square, an attempt to hide the limits of the technology. The images are also stored in a low-resolution pixelated format; this reduces the quantity of information on the disk. Nonetheless, the disks can't pump data fast enough, so video images are displayed in a jerky stop-and-go fashion.

The constraints of CD-ROMs limit and shape their content. In comparison with multivolume encyclopedias, today's CD-ROM encyclopedias seem like *USA Today* compared with a weekly news analysis magazine. Today's CD-ROMs feature short paragraphs, a couple of pictures, and a few sounds. That's it. Just as early film masters learned to use black-and-white film and the silent medium to advantage, we are developing a new aesthetic for CD-ROMs.

WEB CRAWLING

The champions of the on-line networked world argue that the limits of CD-ROM storage capacity are short-term. Don't worry, they

tell us; soon CD-ROMs will be made obsolete by limitless information connected in a worldwide web of on-line networks. In reply we might ask whether they really think we'll ever be satisfied with the "bandwidth" of our connections to the Internet.

Bandwidth—the number of bits that can be transmitted per second through a given channel—is rapidly increasing. Modems running at 10,000 bits per second seemed pretty good for accessing the Internet—until the graphics-intensive World Wide Web became the rage. The tenfold increase in bandwidth delivered by new phone technologies such as ISDN (which can transmit 128,000 bits per second) partly alleviates the pressure on the narrow pipe of a modem. But if you're interested in sound and video, response time on the Web still leaves a lot to be desired—you click and experience a pause, possibly a very long pause. . . .

We're all waiting for high-speed T1 connections that will deliver 1.5 million bits per second to our houses, or for the projected cable modems that promise to deliver even higher-speed connections using the fiber optic lines that bring cable TV to our homes. But what demands will there be on bandwidth when these technologies are finally delivered?

In the meantime, as is the case with so many of the worlds in the digital universe, the constraints become part of the aesthetic. A review of movies on the World Wide Web observes: "On the Internet, feature length is 40 seconds and a wide screen is the size of a box of Good'n'Plenty. Yet these limitations are part of digital video's charm."

THE LIMITS OF DIGITAL COMPUTATION

Moore's law—named for Gordon Moore, one of the founders of Intel—states that the power of microprocessors doubles every eighteen months, as does the capacity of computer memory, hard drives, telecommunications bandwidth, and so on.

The world of digital engineering has even developed a new logic:

wastefulness. Silicon engineers are discouraged from optimizing the space required for circuit designs because time to market is key and silicon capacity is constantly doubling. The aesthetic of software design discourages overoptimizing because memory is cheap and will be even cheaper next year. If the latest version of Microsoft Windows software is slow today, the hardware will catch up soon enough.

Even so, the limits of technology shape everything delivered by digital means. This is true today and will still be true in the future. If computer power doubles, the demands of applications will increase even more. Yes, the size of storage will shortly increase tenfold. Yes, today's animations and video clips will soon look like the scratchy black-and-white images of early film compared to today's high-tech entertainment. But there will always be technical limits. If storage quadruples, then multimedia, video, and virtual reality will expand correspondingly to devour the greater capacity.

Research has suggested that a simulation indistinguishable in quality from the real world will require 85 frames per second, with 1 million–by–1 million pixel resolution, at 16 million colors per pixel, with a range of view of 235 degrees side to side and 100 degrees top to bottom. Any given image might require as many as 800 million distinct surfaces to describe it. These are mind-boggling numbers! They tell us that the limits of the technology are destined to be with us for a long time.

The limits of the computer graphics engines of a given period in the evolution of the technology are evident in the accompanying aesthetic. Digital artists animate complex figures with resolution to match. They render images without hair or skin because it's impossible to render hair realistically. This results in an aesthetic in which you know the image is computer-generated and you marvel at the rendering and how it dealt with certain complex issues of computation. But you know and accept that other difficult problems—difficult within the limits of the technology—have been gracefully sidestepped. This grace is a fundamental part of today's digital aesthetic.

Back in Neal Stephenson's Metaverse, it is only in the context of the limits of the technology that Mr. Ng can discreetly display the ultimate status symbol of an avatar. His immense wealth and power are subtly reflected in the anything-but-leisurely demands on computing when he is simply "lighting up a cig. The smoke swirls in the air ostentatiously. It takes as much computing power realistically to model the smoke coming out of Ng's mouth as it does to model the weather system of an entire planet."

THE LIMITS OF BITS

We've already seen that all things digital are ultimately reduced to bits: either 0 or 1. Consequently, all the examples of the limitations of digital technology are about bits of information: how many bits of information can be processed per second; how many bits of information can be stored; how quickly bits can be accessed from a storage device; how many bits can be moved through a connection to the Internet. Herein lies the nature of the digital.

And herein lies the ultimate limitation of digital technology. It's binary: 0 or 1. It's discrete. Discontinuous. As fine as the granularity may be of any digital representation, even zooming in for seemingly infinitesimal resolution, there is ultimately a 0 or a 1.

Yet the world as we experience it is an analog place. It's a constant stream; our experience of time, our views of reality, our thoughts, and our consciousness are not broken into consecutive discrete segments. Even when an extremely fine resolution grid is applied to create a discrete digital representation of some analog form; even if our experience of a digital world seems continuous—it's not. Ultimately there is a 0 or a 1. By its nature, the digital world is discontinuous, so there will *always* be a gap of some sort in any digital representation.

There are other ways to represent information. But if they're not in binary form, they're not digital in the way we understand the digital today. We may one day have other options—biocomputers; neo-analog computers. And these in turn may open up new possibilities

and new worlds. Today, however, when we peel away the layers of a digital world, strip it down to the equivalent of the flatness of Stella's canvas, we find only the binary nature of digital processes. This is the true limit of the digital world: it cannot represent anything that is not ultimately reducible to either 0 or 1.

9

Mosaics

WH E N you open a book, you may glance over the contents page and see how the book is broken into parts or chapters. You look at the title of each chapter to get a sense of the book. You flip through the pages from beginning to end.

You expect that the ideas presented in the book will follow a straight line. The story or argument takes the form of a seemingly *necessary* structure, with a definite start and a definite end. It progresses on the basis of clear notions of logic and sequential succession. Earlier chapters and events point to what follows. It's linear.

This linear logic is rooted in the alphabet and the written word, which have been the foundation for Western culture for millennia. Letters form words, which in turn are organized into sentences. The logic of the written word is that one idea leads to the next, sentence by sentence, page by page, in a forward-moving succession from start to finish.

Following the invention of the alphabet, writing developed over thousands of years into today's systems for recording, organizing, storing, and retrieving information and knowledge. During this time, the alphabet and written word have shaped our literary traditions into linear form.

In fact, <u>McLuhan</u> proposed that there is a link between phonetic literacy and the linear bias of Western thought. He suggested that the linearity of the alphabet and of writing has shaped our notions of rational thought and made them different from the thought patterns of nonalphabetic cultures. Our very concepts of rationality and valid argument are bound up with a way of thinking derived from the alphabet and writing as a medium. McLuhan concluded that, as a result, today we define rational thought itself as a sequential process, progressing from A to Z.

> During all our centuries of phonetic literacy we have favored the chain of inference as the mark of logic and reason. . . . [We] say that something "follows" from something, as if there were some cause at work that makes such a sequence. . . . [We find] the hidden cause of our Western bias toward sequence as "logic" in the all-pervasive technology of the alphabet.
>
> MARSHALL MCLUHAN,
> *Understanding Media*

In sharp contrast to the alphabet, the nature of digital technology is random access. It's *non*linear. A computer can retrieve information from any part of its RAM (random access memory) in less than a millionth of a second. With a hard disk it may take thousandths of a second. We are blinded by digital speed. With such rapid access time, it's equally easy to jump from one page to the next and from the first page to the last. In effect, anything stored in digital form can be accessed at any time and in any order.

Nonlinearity is a fundamental property of *digital* worlds. And it's only as the foundation of logic shifts from the linear to nonlinear that we will completely discover the *new* in the digital. Just as the linear nature of the alphabet is reflected in the form of the book, the nonlinear nature of digital worlds is part of digital expression, which doesn't start at A and end at Z. There's no beginning, middle, or end. Ideas conceived in digital terms take shape in nonlinear forms.

MOSAICS

The movement to nonlinear expression hasn't just suddenly emerged. In fact, the earliest signs of nonlinear logic appeared in 1844 with Samuel Morse's first public demonstration of the telegraph.

The telegraph initiated the era of worldwide electronic communications and was a catalyst for the development of <u>mosaic</u> media. Like a mosaic, the telegraph's dot and dash signals are discontinuous, not uniform.

The telegraph's discontinuity shaped the modern newspaper. The telegraph made it possible to deliver current reports on a variety of events from near and far. Reports of news events on the other side of the planet were transmitted around the world in seconds.

> The mosaic is not uniform, continuous, or repetitive. It is discontinuous, skew, and nonlineal. . . . Iconographic art uses the eye . . . to create an inclusive image, made up of many moments, phases, and aspects of the person or thing.
>
> MARSHALL MCLUHAN,
> *Understanding Media*

The lengthy articles and literary viewpoint of the newspapers that preceded the telegraph were displaced. The newspaper became a collection of snippets of information concerning world events. The telegraph also shortened the sentence. The transmission of messages from great distances, and often at great expense, demanded economy of expression.

The front page of a paper presents a picture of the news made up of the many moments and events of the world. It reflects the telegraph's signals of dots and dashes in the discontinuous variety and incongruity of day-to-day news. The dots and dashes are translated into the fragmented mosaic of the newspaper.

U.S. Attacks Military Targets in Iraq

Trailing, Dole Vows A Touch of Truman

By ADAM NAGOURNEY

ST. LOUIS, Sept. 2 — Invoking the come-from-behind victory of Harry S. Truman 48 years ago, Bob Dole opened his fall campaign today by describing this year's contest as a vivid choice between "old-style liberal vision" and a conservative vision that would roll back the Government. Mr. Dole devoted more than one-third of his speech to his promise of a tax cut.

At a hot and sweaty Labor Day kickoff rally here, with the 630-foot Gateway Arch before him and the graceful St. Louis skyline at his back, Mr. Dole framed the election as a debate over cutting taxes and reducing the size of Government. In so doing, he reminded his audience both of President Clinton's failure to implement a 1992 promise to cut taxes, and of his own campaign-signature pledge to slash taxes for businesses and individuals.

"This election is about two different visions of America's future," Mr. Dole said, squinting into the bright late-morning sun, his voice booming over the sound system and down to the Mississippi River.

"Our opponents offer an old-style liberal vision that puts government first," Mr. Dole continued. "And Jack Kemp and I offer an optimistic vision that puts the American people first. That's the difference. That's the key dividing line in this campaign. They believe in government, and we believe in you."

Continued on Page D10, Column 1

President Clinton campaigned in Milwaukee.

Paul Hosefros/The New York Times

Pentagon Says Command Site Was Struck

By STEVEN LEE MYERS

WASHINGTON, Tuesday, Sept. 3 — The United States early today launched a cruise missile attack on military and command targets in Iraq in retaliation for its incursion into the northern Kurdish enclave.

The Pentagon, in a statement released at 1:55 this morning, announced the attack, saying the missiles were aimed at Iraq's anti-aircraft batteries and command centers. The statement provided no further details, and an official at the White House declined to specify the targets, the extent of the retaliation or the American forces involved.

"At the direction of the President, the Department of Defense has launched cruise missiles to attack selected air-defense targets in Iraq," the statement said.

The Pentagon said President Clinton would discuss the attack at the White House at 8 A.M.

The decision to use cruise missiles reflected concerns about putting American pilots at risk. It was not clear whether the air assault represented the first wave of a prolonged attack or a single strike.

In Baghdad, air raid sirens resounded at 9:25 A.M. (1:25 A.M. Eastern time), but there were no immediate reports of what areas were hit or what damage was caused.

Iraqis, hardened by two recent wars and stifling economic and social conditions, ignored the warning, The Associated Press reported. There was no visible panic among motorists and pedestrians filling the streets during the morning rush hour.

On Monday, the Clinton Administration said Iraq appeared to be pressing deeper into Kurdish areas and was executing political opponents.

Michael D. McCurry, the White House spokesman, said President Clinton had decided on "a defined course of action" against Mr. Hussein.

Iraq's forces withdrew from the center of Erbil early on Monday, but Mr. McCurry and other Administration officials said Iraqi troops, backed by tanks and artillery, remained arrayed around the city and inside the exclusion zone created by the United States and its allies five years ago to protect the Kurds.

"We see no indication that they are preparing withdrawal back to their original forward positions," said Mr. McCurry, who was traveling with the President aboard Air Force One on the way to campaign stops in Wisconsin. He added that the pullout was "not terribly significant because they still have a significant force arrayed around Erbil."

Aid workers arriving at Iraq's border with Turkey on Monday after fleeing Erbil said Iraqi soldiers had

Continued on Page A6, Column 1

David Cone facing the Oakland A's in his dramatic return to the Yanks.

Peter Richter for The New York Times

Sensational Comeback for Cone: Seven Innings, No Runs, No Hits

By JACK CURRY

OAKLAND, Calif., Sept. 2 — David Cone's incredible comeback story evolved into an unbelievable pitching tale today when he returned to the Yankees less than four months after surgery to remove an aneurysm from under his right armpit and no-hit the Oakland Athletics during his seven-inning appearance.

Cone left the game after throwing 85 pitches because Manager Joe Torre did not want him to overtax his surgically repaired right shoulder. He was replaced by Mariano Rivera, who fell two outs short of completing the no-hitter when Jose Herrera managed an infield single off third baseman Charlie Hayes's glove with one out in the ninth inning. Rivera finished the Yankees' 5-0 victory at

the Oakland Coliseum.

"I'll never wonder if this could have been my last opportunity to throw one," Cone said of the delicate decision to not allow him to try to complete the no-hitter. "I wouldn't think that way. I appreciate that they took me out of the game. It's more important for us to get to the playoffs and the World Series.

Before the game, Torre had said he would not allow Cone to throw more than 100 pitches. Torre insisted his decision to protect Cone for the sake of the pennant race was fairly simple.

"If I would have left him in to throw 105 or 106 pitches and his shoulder would have been achy tomorrow or down the road, I never would have been able to live with myself," Torre said. "I would have always regretted it."

It was a stunning and sweet afternoon for Cone, 33, a Cy Young award-winning pitcher who had wondered whether his 11-year career was over, and for the Yankees, who had not expected him to make it back to the mound this season but now hope he will be the boost the lethargic team needs to maintain first place in the American League East.

After undergoing surgery on May 10 to remove the aneurysm and replace the affected section of artery with a one-inch vein graft, Cone did not throw a baseball again until June 26. After a month of condition-

Continued on Page B9, Column 5

Bell Atlantic's Litany of Snags In Mexico Deal

By JULIA PRESTON

MEXICO CITY, Sept. 2 — In the first heady days of the free-trade pact between the United States and Mexico, the Bell Atlantic Corporation spent more than $1 billion to buy a piece of a feisty Mexican cellular telephone company that had big plans to grow.

Bell Atlantic's stake in the company, Grupo Iusacell, remains one of the largest single American investments in Mexico since the North American Free Trade Agreement went into effect, and one of the deals that American business is watching to judge how that accord works. But Bell Atlantic has run into a dizzying obstacle course in this country that has blocked it from starting up a local telephone service, which is central to its expansion strategy.

In the most recent setback, the American telecommunications giant was ensnared in the scandal surrounding Raul Salinas de Gortari, the brother of a former President, who is in jail on charges of "illegal enrichment" and money-laundering, among other charges. Bell Atlantic, which is currently involved in a $20.8 billion merger with the Nynex Corporation, became the first American company to suffer direct financial losses as a result of the scandal.

Only now, after two years of negotiations with the Government and lobbying by top American officials, is Bell Atlantic on the verge of breaking a regulatory logjam that cost it tens of millions in potential business.

Continued on Page D2, Column 1

Roughing It for Class

Colleges are encouraging students to backpack, canoe and camp together to get to know one another before starting their class work.

Article, A16.

Seminarian Held on Bomb Charge at Airport

By ROBERT D. McFADDEN

Roman Regman, 21, who lives with his mother in Florida and has been studying at a Pennsylvania seminary for a priesthood in the Orthodox Church in America, hardly fit the profile of a terrorist bomber or hijacker. His manner at Tampa International Airport was polite, deferential, calm and composed.

In a strange encounter at a security checkpoint on Saturday — an incident whose circumstances are hotly disputed by the man's mother, who

was there — officials said Mr. Regman, a Romanian immigrant who had spent the summer with his mother and was returning to his seminary near Scranton, hoisted his camouflage knapsack and his black canvas duffel bag onto an X-ray machine conveyor belt.

But, officials said, the luggage was too tightly packed for attendants to scan the contents. And when attendants said they would have to hand-search his luggage, Mr. Regman volunteered that he had a gun in one of his bags. They looked in and, sure

enough, found an unloaded 9-millimeter Beretta pistol. Mr. Regman did not flee and offered no resistance as the police were summoned.

In a security office minutes later, the police said they found an arsenal in his luggage: two live hand grenades with timing devices, five other explosive devices, what was described as a variety of bomb-making materials, 100 rounds of ammunition for the 9-millimeter pistol, 100 rounds of ammunition for a .22-caliber weapon, six military-style knives, a ski mask and black gloves.

Authorities said the explosives were easily powerful enough to have brought down the USAir flight to Pennsylvania that Mr. Regman had intended to take. And with tension high at airports across the country since the Trans World Airlines explosion that killed 230 people off Long Island in July, officials said the arrest was significant and might have averted another disaster.

Mr. Regman, who made no statement, was being held without bond at the Hillsborough County Jail near Tampa yesterday on seven counts of possessing explosive devices and seven counts of possessing concealed weapons. Federal officials said the

Continued on Page D9, Column 1

In the Lead, Clinton Plays the Underdog

By TODD S. PURDUM

MILWAUKEE, Sept. 2 — President Clinton wound up nine days of intense campaigning with a brace of Labor Day celebrations in Wisconsin today, one at a picnic on traditionally Republican turf near Green Bay and the other in an old-fashioned evening rally with liberal leaders of big labor in Milwaukee.

The day amounted to a metaphor for Mr. Clinton's yearlong campaign strategy: appeal to moderate voters and Reagan Democrats to edge his electoral support above 50 percent while rallying support among traditional Democratic constituencies like women, labor and minorities to shore off any challengers and spark turnout in November.

"God bless you!" the President exclaimed to one woman among the 25,000 people who packed Voyageur Park in De Pere, just outside Green Bay, and who was holding up a homemade black-and-white sign proclaiming "Republicans for Clinton." He added: "I wish I could sign that for you. Give her a hand."

Both in De Pere, and later here in Milwaukee, where he appeared with John J. Sweeney, the president of the A.F.L.-C.I.O., and Gerald W. McEntee, president of the American Federation of State, County and Municipal Employees, Mr. Clinton lit into Bob Dole's proposed 15 percent tax cut as impractically large and sure to "explode the deficit" and force cuts in domestic spending, while promoting his own smaller tax breaks for education as just right.

Continued on Page D11, Column 1

Bob Dole held a Labor Day rally in St. Louis.

Agence France-Presse

Agency Had Noted Problems in Home Where Girl Starved

By MATTHEW PURDY

The head of New York City's Administration for Children's Services acknowledged yesterday that evidence of neglect was found 15 months ago at the home of Nadine Lockwood, the 4-year-old girl who investigators say was starved to death by her mother. But he said that after an initial review of records, he could not say what action, if any, was taken by city social workers.

There was a long history of contact between child welfare workers and the Lockwood family, which was investigated several times for child neglect — twice after Nadine and another child were born with drugs in their system and at other times, when friends or neighbors called child welfare officials.

Nicholas Scoppetta, the Commissioner of Children's Services, said yesterday that city investigators found enough "credible evidence" of neglect to open an investigation when they visited the apartment in Washington Heights in May 1995 after an anonymous complaint about Nadine's treatment. But based on the records available to him yesterday, he said he was unable to say what conditions were found or what further action was taken. The case was

Continued on Page B4, Column 1

INSIDE

A Battle Brews Over Jobs

A bill on Governor Pataki's desk would give some of Mayor Giuliani's power over economic development to the borough presidents. Page B1.

Future of Tennis Goes 1-1

Two 15-year-olds tried to advance to the United States Open round of 16 yesterday, and one — Martina Hingis — did. SportsTuesday, page B7.

Calm Instead of the Storm

New Yorkers, including one enjoying the Hudson River from Wave Hill in Riverdale, basked in sunshine and a high just short of the 90-degree mark

yesterday, a Labor Day that forecasters had said might be ruined by Hurricane Edouard. Instead, the storm moved to sea. Page A12.

Librado Romero/The New York Times

354613

The rhythm of expression was altered in both format and experience. Our experience of reading a newspaper, unlike that of reading a book, is discontinuous. You visually sweep a paper's front page to capture a sense of what's happening in the world. You absorb a picture, headline, caption, and some text in one glance. You spread the paper over your desk and read what catches your eye or intrigues you, skipping from one article to another, not necessarily completing any of them. There is no fixed beginning or end; you select a beginning when you jump straight to the business or sports page, and the end whenever you put the paper down. You scan a story, turn pages for more, and turn back easily to the beginning. You skip to the paragraph that summarizes the conclusion. As with a mosaic, you build an image of the day's news from various pieces of information. The modern newspaper, shaped by the telegraph, presages qualities of the digital age.

THE SHIFT TO NONLINEARITY

Our communications rapidly shifted to electronic media; today, we're shifting to digital media. These new vehicles provide new systems for recording and retrieving information. The 1981 debut of MTV perhaps best represents the demarcation line between the old and the new.

MTV was the first widely popular medium to exploit electronic media's ability to simultaneously present several different stories juxtaposed with quick cuts produced by video editing. MTV challenged our sensory capacity with vivid imagery, rapid cuts, and intense electronic sounds—and prepared us for more. Testing our audio and visual limits, it discovered no boundaries and an insatiable demand.

Today nonlinearity is permeating all parts of our <u>culture</u>. And as

> An acid trip, a new cyberpunk novel, a quick-cut MTV video, or a night at a "house music" club can provide the same hypertext-style experience. The rules of linear reality no longer apply. Meanwhile, as evidenced by quantum physics and chaos math, numbers and particles have ceased to behave with the predictability of linear equations. Instead, they jump around in a discontinuous fashion, disappearing, reappearing, suddenly gaining and losing energy. Our reality, scientists are concluding, can no longer be explained by the simple, physical, time-based rules of law and order.
>
> Douglas Rushkoff, *Cyberia*

these new discontinuous media permeate our life, they are changing not only our way of thinking, but even our perception of reality. Soon we will no longer expect a beginning, middle, and end. Instead, we will expect the freedom to jump in a discontinuous fashion, from idea to idea, independent of the constraints of space and time.

Ultimately, the computer and new digital media will reshape the very ways we think, just as the linear nature of the alphabet has shaped our thinking and influenced our intellectual world for thousands of years. Digital media are a dramatic departure from print-based linearity. We're shifting from the logic of literacy to the somewhat arbitrary serendipity of nonlinearity.

In contrast to the alphabet and written word, digital media are characterized by the capability to access any random point and then easily jump to another—whether the points are pages in a word processor, information on a disk or storage device, or digital worlds located anywhere in the universe linked by the Internet. The jumps at "warp speed" that once were limited to the domain of science fiction are increasingly an accepted part of our culture.

> There was a queer momentary sensation of being turned inside out. It lasted an instant and Baley knew it was a Jump. That oddly incomprehensible, almost mystical, momentary transition through hyperspace that transferred a ship and all it contained from one point in space to another, light years away. Another lapse of time and another Jump, still another Jump, still another Jump.
>
> ISAAC ASIMOV, *The Naked Sun*

THE NONLINEAR HYPERLINK

The digital pioneer Ted Nelson first coined the term "hypertext" in the 1960s to describe a system of nonsequential writing: "text that branches and allows choices to the reader." In the seventies, he expanded this notion to "hypermedia" to describe a new media form that utilized the power of the computer to store, retrieve, and display information in the form of pictures, text, animations, and sound.

The essential enabler of hypermedia is the hyperlink—a special "link" that "points" to other available information. With today's technology—whether it's a multimedia CD-ROM, the World Wide Web, or a virtual world—you point and click on a highlighted link and the referenced information automatically appears. Hyperlinks can be placed within any "page." You simply click from one page to another, with the potential to hop around a vast world of information. With multiple hyperlinks in any given context, and with links to other links and still other links, myriad paths can be traveled. Combined with the multimedia capabilities that make possible the mixing of text, graphics, audio, video, and even dynamic virtual worlds, the hypermedia made possible by digital technology represent truly new media.

Reading a hyperlinked work in linear fashion has roughly the same vestigial meaning as going through a newspaper page by page. Rather, you jump from here to there to somewhere else and back, rarely reading a complete paragraph without digressing. You select what interests you and determine how deeply you want to delve into a subject. The process of navigating in this way is interactive. Navigation responds to your choices. Your reading or experience of traveling through a hyperlinked world of information isn't predetermined; it involves you in a way no other medium has before. You can lose yourself in a labyrinth of pathways or return to familiar ground. The experience doesn't have a clearly defined beginning, middle, or end. It's an adventure.

Exploring a hypermedia world is an interactive, discontinuous experience of information that, like a mosaic, is made up of "many moments, phases, and aspects of the person or thing." Built on the concept of a connection between two points in digital space—the "hyperlink"—digital media represent a radically new, nonlinear form of expression. The tradition of linearity, sustained narrative, and cohesive argument is coming to an end.

LINKS OF ASSOCIATION

Although our notions of logic and rational thought have been shaped by the linear sequence of the alphabet and the written word, perhaps the discontinuity of hyperlinks reflects the way our minds naturally work.

Memory seems to be an accumulation of traces of experiences linked by association. Recreating the associative connections of the mind was the goal of Vannevar Bush's memory extension system called Memex, a precursor of Nelson's hyperlinks, that was first outlined in 1945. Bush described Memex as a system that could store text and images that would be accessed with associative indexes whose functioning would resemble the way he believed information is linked by the human mind. Influenced by Bush, Nelson also believes that hyperlinks and associative connections represent a way of navigating through information that mimics how we actually think.

More recently, the computer scientist Marvin Minsky has proposed a theory of how the mind works, based on what he calls Knowledge-lines (K-lines). K-lines branch out to form connections among related memories of our experiences. Minsky describes strong K-lines and weaker ones and discusses how new K-lines become connected to old ones. In all, the links and associations create a web of connections that form what he calls a society of mind.

Perhaps, as we consciously master new forms of logic that better reflect the workings of our minds, we will discover largely untapped powers of the human mind. Freed from the constraints of linear

> Consciousness is regarded as the mark of a rational being, yet there is nothing lineal or sequential about the total field of awareness that exists in any moment of consciousness.
>
> MARSHALL MCLUHAN,
> *Understanding Media*

> The human mind . . . operates by association. With one item in its grasp, it snaps instantly to the next that is suggested by the association of thoughts, in accordance with some intricate web of trails carried by the cells of the brain.
>
> VANNEVAR BUSH,
> "As We May Think"

form, we may unleash our imaginations to explore entirely new aspects of human potential.

GROUND RULES FOR NONLINEAR SPACE*

Nonetheless, today, as we enter this nonlinear space for the first time, we quickly realize that there are very few ground rules. How do we integrate discontinuity within a single structure? Digital worlds must develop new languages of coherence.

To master random access, encyclopedias and dictionaries use linearity—alphabetical and chronological ordering and alphabetical indices. In contrast to reference books that provide mechanisms to "get in," digital media without nonlinear hyperlinks induce severe claustrophobia. There must be a way out. On a computer screen, linear text is as awkward as the first movies at the turn of the century, when the movie camera didn't move. We demand the freedom of digital worlds to be able to jump at warp speed whenever we so desire.

A K-line is a wirelike structure that attaches itself to whichever mental agents are active when you solve a problem or have a good idea. When you activate that K-line later, the agents attached to it are aroused, putting you into a "mental state" much like the one you were in when you solved that problem or got that idea.

MARVIN MINSKY,
The Society of Mind

Bill's Naked Lunch Room.... *Step right up.... Good for young and old, man and bestial. Nothing like a little snake oil to grease the wheels and get a show on the track Jack. Which side are you on?*

It's clear which side William Burroughs is on. He wanted to be free of all restraint. To this end, he created a revolutionary "montage language" for his writing. He didn't impose continuity. There's no story line or plot. He rejected conventional logic. The result was radical.

Burroughs suggests that he didn't so much write *Naked Lunch* as act as a recording instrument of his drug-induced experience. Alternatively,

*For discontinuous audio accompaniment, turn on a radio and press <SCAN>. Leave the radio scanning.

he saw himself as Lazarus returned from the dead to tell us what he had seen.

> The Word is divided into units which be all in one piece and should be so taken, but the pieces can be had in any order being tied up back and forth, in and out fore and aft like an innaresting sex arrangement. This book spill off the page in all directions, kaleidoscope of vistas, medley of tunes and street noises, farts and riot yipes and the slamming steel shutters of commerce, screams of pain and pathos and screams plain pathic, copulating cats and outraged squawk of the displaced Bullhead, prophetic mutterings of brujo in nutmeg trance, snapping necks and screaming mandrakes, sighs of orgasm, heroin silent as the dawn in thirsty cells, Radio Cairo screaming like a berserk tobacco auction, and flutes of Ramadan fanning the sick junky like a gentle lush-worker in the grey subway dawn feeling with delicate fingers for the green folding crackle.

Rather than laying down a clear-cut linear sequence from A to Z, the digital experience brings all the components of the medium into a matrix that can be freely explored. Like buildings, with their start-anywhere go-anywhere architectural design, digital worlds structure the relationships between every part of a start-anywhere go-anywhere experience delivered in the digital domain.

Digital works need a new coherence that considers the different paths of nonlinear space. They need links that push the reader from one digital experience to the next. If a work is to be more than a collection of seemingly arbitrarily related material, it requires a logic that delivers its message independent of the order in which it is delivered.

> Print gave intensity and uniform precision, where before there had been a diffuse texture. Print brought in the taste for exact measurement and repeatability that we now associate with science and mathematics.
>
> MARSHALL MCLUHAN,
> *Understanding Media*

THE TEXTURE IS THE MESSAGE

We can find clues to these new languages by looking at how the linear has come to shape expression. Unlike <u>print media,</u> the

nonlinear languages of digital hypermedia must return to the diffuse.

Repeatability is a quality hypermedia lacks. It must be assumed that no two people will experience the same work in the same order. Instead of a deterministic experience, there is a texture of experience. Hypermedia undoes the scientific, the precise, to create instead a "diffuse texture" similar to what pre-dated print technology. Nonlinear digital worlds create complete sensory environments that evoke a sense of their wholeness.

The best of nonlinear media will create an experience that reveals a new logic. We will be immersed in the texture of a nonlinear sequence that's as compelling as going from A to Z. As we freely explore, links push us from world to world in a narrative-audio-image-photo-video-essay. Sparse text merges with images that reflect the emotional world of the words. There are links in every direction. Arriving at a special location, it's possible to dive deep. However, even though it's possible to dive deeper and deeper into a subject, hypermedia is characterized by jumps. Lots of them. This may seem like a mass of confusion to a generation unaccustomed to today's new discontinuous media but is the norm for a generation growing up immersed in it. Anyone accustomed to MTV can surf multiple TV channels and absorb the story lines of multiple programs. "I can surf twenty TV channels at once," boasts a trainee of MTV.

Prior to MTV, it was assumed that no one would be able to make sense of an edit shorter than about two seconds. Today, videos regularly use edits of a third or a quarter of a second, even "flash frames" of a tenth of a second. Just as moving a movie camera defined film as a medium distinct from photography, the quick cuts introduced by MTV have redefined our visual languages; they have integrated the discontinuity of electronic media into an entirely new language of expression.

Today, kids are introduced to on-line digital worlds at the same time that they first see MTV. The discontinuity of digital media will define entirely new languages of expression. Their senses are being tuned to the nonlinearity and dense sensory experiences of these emerging digital worlds.

One day, while cutting a mount for a drawing, the writer Brion Gysin sliced through a pile of newspapers with his Stanley knife. Out of the strips of paper he made a mosaic that he found visually interesting. Later, Burroughs returned to the house and, seeing the mosaic, saw in it a technique to escape from existing concepts of the novel.

Meeting Samuel Beckett at a dinner, Burroughs explained his method: "What I do is I take a page of my writing and a page from the *Herald Tribune;* I cut them up and then I put them back together, and I gradually decipher new texts. Then I might take a page of your writing, and line it up with what I already have, and do the same thing all over again."

Burroughs had discovered in Gysin's mosaic a way to create an endless reel of images, scenes, and characters with the same degree of discontinuity as his "recordings" of his drug-induced fantasies.

Burroughs set a standard. The discontinuity of his writing is masterful. His pace is intense as he pushes you from page to page, climaxing in an explosion of ecstasy.

While most books are meant to be read through from the first page to the last, Burroughs demonstrates how a writer can deliver suspended disbelief and a cohesive narrative in a completely discontinuous world. Burroughs abandoned linearity for collages of words transformed by splicing, cutouts, fold-ins, and taping. His works are montages of images erupting in seemingly random series. Burroughs approached writing as a plastic art and molded an incoherent and discontinuous series of images into a remarkable reflection of his drug-driven hell. Everything is experienced on the edge. His writing masters the discontinuity of hyperlinks.

NAKED Lunch—a frozen moment when everyone sees what is on the end of every fork.

The mosaics in our future will not take the form of newsprint or video. Instead we'll jump from one digital domain to another via links that knit a new mediasphere. As we travel these links, our imaginations will relish the freedom to pursue any path to anywhere, weaving textures on the eclectic postmodern frontiers of information. We'll take delight in nonlinear forms and savor the many moments, phases, and aspects of "digital mosaics."

CONCLUSION

10

Don't Look Back

Fₒ ᵣ centuries, the book has been the primary vehicle for recording, storing, and transferring knowledge. But it's hard to imagine that paper will be the preferred format in a hundred years. Digital media will marginalize this earlier form of communication, relegating it to a niche just as music CDs have replaced LPs. The book will be forced to redefine itself, just as TV forced radio to redefine itself, and radio and TV together transformed the newspaper's role. The process is survival of the fittest—competition in the market to be a useful medium. Whatever the book's future is, clearly its role will never be the same. The book has lost its preeminence.

The print medium of newspaper is also fading. Almost every major newspaper in the United States is experiencing significant declines in circulation. (The exception is *USA Today*—characterized by itself as "TV on paper.") More than 70 percent of Americans under the age of thirty don't read newspapers. And this trend isn't about to change.

The powers of the media business today understand this. As part of the frenzied convergence of media, communications, and the digital world, we're witnessing a dizzying tangle of corporate alliances and mega-mergers. Companies are jockeying for position for this epochal change. The list includes many multibillion-dollar companies—AT&T, Bertelsmann, Disney, Microsoft, Time Warner,

Viacom—and many, many more small startup technology compa-nies. They all want to position themselves as preeminent new media companies.

CLINGING TO THE PAST

Members of the literary establishment can also see this imminent change. Yet, for the most part, they take a dim view of these new digital worlds. Beyond the loss of their cherished culture, what dis-turbs many critics is that they find new digital media like CD-ROMs and the World Wide Web completely unsatisfying.

The literary critic Sven Birkerts eloquently laments that the gen-eration growing up in the digital age is incapable of enjoying litera-ture. Teaching at college has brought Birkerts to despair because his students aren't able to appreciate the literary culture he so values. After only a proudly self-confessed "glimpse of the future" of CD-ROMs, he declares he is "clinging all the more tightly to my books."

The disillusionment with the digital experience is summed up by the *New York Times Book Review* critic Sarah Lyall. She complains that multimedia CD-ROMs

> still don't come close to matching the experience of reading a paper-and-print book while curled up in a chair, in bed, on the train, under a tree, in an airplane. . . . After all, the modern book is the result of centuries of trial and error during which people wrote on bark, on parchment, on vellum, on clay, on scrolls, on stone, chiseling char-acters into surfaces or copying them out by hand.

Okay, I thought as I read Birkerts and Lyall, these are members of a dying cultural heritage who—like seemingly every genera-tion—are uncomfortable with the new. Unable to shift their per-spective, they'll be casualties of change. After all, Birkerts boasts that he doesn't own a computer and still uses only a typewriter.

Birkerts clings not to his books, but to the past. I was reminded of a comment by the cultural critic William Irwin Thompson, who is also wary of the consequences of digital technology:

It is not the literary intelligentsia of *The New York Review of Books* [or *The New York Times,* as the case may be] that is bringing forth this new culture, for it is as repugnant to them as the Reformation was to the Catholic Church. . . . This new cyberpunk, technological culture is brought forth by Top and Pop, electronic science and pop music, and both the hackers and the rockers are anti-intellectual and unsympathetic to the previous Mental level expressed by the genius of European civilization.

This helped me dismiss the backlash from those looking in the rearview mirror. But then I came across a book by Clifford Stoll.

MUDDIER MUD

Stoll, who was introduced to computers twenty years ago, is a long-time member of the digerati. In his book *Silicon Snake Oil,* he claims to expose the true emptiness of the digital experience.

In opening, Stoll explains that "every time someone mentions MUDs [multi-user dungeons, a type of interactive adventure game] and virtual reality, I think of a genuine reality with muddier mud than anything a computer can deliver." Stoll then nostalgically recounts the story of the first time he went crawling through caves in his college days. "We start in, trailing a string through the muddy tunnel—everything's covered with gunk, as are the six of us crawling behind [the guide]. Not your ordinary slimy, brown, backyard mud, either. This is the goop of inner-earth that works its way into your hair, socks, and underwear."

Stoll's general theme: "You're viewing a world that doesn't exist. During that week you spend on-line, you could have planted a tomato garden. . . . While the Internet beckons brightly, seductively flashing an icon of knowledge-as-power, this nonplace lures us to surrender our time on earth."

I suppose this excludes any experience that might distract us from the real—a novel, a Beethoven symphony, a movie. (A tomato garden?)

And then we get the same theme that Birkerts and Lyall hit on.

I've rarely met anyone who prefers to read digital books. I don't want my morning newspaper delivered over computer, or a CD-ROM stuffed with National Geographic photographs. Call me a troglodyte; I'd rather peruse those photos alongside my sweetheart, catch the newspaper on the way to work, and page through a real book. . . . Now, I'm hardly a judge of aesthetics, but of the scores of electronic multimedia productions I've seen, I don't remember any as being beautiful.

A CD-ROM IS NOT A BOOK

These laments totally miss the point. No, a CD-ROM isn't a book. Nor is a virtual world—whether a MUD or a simulation of rolling in the mud—the same as the real experience. This is *exactly* the point! A CD-ROM isn't a book; it's something completely new and different. A MUD on the Internet isn't like mud in a cave. A virtual world isn't the real world; it offers possibilities unlike anything we've known before.

Birkerts, Lyall, and Stoll dismiss the digital experience to justify staying in the familiar and comfortable worlds of their past. Yet what's exciting to me about these digital worlds is precisely that they're new, they're unfamiliar, and they're our future.

It's not that I disagree with the literati's assertions. We will lose part of our literary culture and tradition. Kids today are so attuned to the rapid rhythms of MTV that they're unresponsive to the patient patterns of literary prose. They are indeed so seduced by the flickeringly powerful identifications of the screen as to be deaf to the inner voices of print. Literary culture—like classical music and opera—will become marginalized as mainstream culture pursues a digital path.

There never will be a substitute for a book. And today's multimedia CD-ROM—even surfing the World Wide Web—is still for the most part a static and unsatisfying experience. But it's rather early to conclude anything about their ultimate potential.

PATIENCE IS A VIRTUE

It puzzles me that there are people who expect that, in almost no time at all, we'd find great works by those who have mastered the subtleties of such completely new digital worlds. We are seeing the first experiments with a new medium. It took a long time to master the medium of film. Or the book, for that matter. It will also take time to master new digital worlds.

It's challenging to create a multimedia digital world today. The enabling technologies that will make radically new digital worlds possible—Java, VRML, and a string of acronymic technologies—are still emerging. Artists, writers, and musicians must also be software programmers. Today, a rare combination of passion, artistry, and technical knowledge is required. Yet, over time, these skills will become common. Even more important than the technical mastery of new digital media, a new conceptual framework and aesthetic must also be established for digital worlds.

When this conceptual and technical mastery is achieved, we'll discover the true possibilities of digital expression. In a few decades—or possibly in just five years—we'll look on today's explorations as primitive. Until then, we will continue to explore these new digital worlds and seek to learn their true potential.

EMBRACING THE DIGITAL

There will be nothing to replace the reading of a book or newspaper in bed. Curling up by a fireside to read a poem with an electronic tablet won't have the same intimacy as doing so with a book. But curling up by a fireside with an electronic tablet is itself simply an example of substituting electronic technology for an existing medium—extrapolating from today's flat-paneled handheld computers to an "electronic book." We need to develop a new aesthetic—a digital aesthetic. And the emerging backlash from the literati makes clear to me how urgently we need it.

When we've mastered digital media, we won't be talking about anything that has much to do with the antiquated form of the book.

I imagine myself curled up in bed with laser images projected on my retinas, allowing me to view and travel through an imaginary three-dimensional virtual world. A story about the distant past flashes a quaint image of a young woman sitting and reading a book, which seems just as remote as the idea of a cluster of Navajo Indians sitting around a campfire and listening to a master of the long-lost tradition of storytelling. In a hundred years, we'll think of the book as we do the storyteller today.

Will we lose a part of our cultural heritage as we assimilate new media? No doubt. Is this disturbing? Absolutely. Today's traditional media will be further marginalized. Is there much value in decrying an inevitable future? Probably not. The music of *today* is written on electric instruments. Hollywood creates our theater. And soon digital media will be *our* media. Digital technology and new digital media—for better or worse—are here to stay.

That's not to say that all things digital are good. Perhaps, like the Luddites in Britain during the first half of the nineteenth century, the literati raise a flag of warning, raise awareness, and create debate, debunking some of the myths of a utopian digital future. But in the end, for better or for worse, the efforts of the Luddites were futile when it came to stopping the industrial revolution.

Likewise, today you can't turn off the Internet. Digital technology isn't going away. There are already thousands of multimedia CD-ROMs and hundreds of thousands of sites on the World Wide Web; soon there will be thousands of channels of on-demand digital worlds.

Digital technology is part of our lives, a part of our lives that we know will only continue to grow. We can't afford to dismiss it. Rather we must embrace it—not indiscriminately, but thoughtfully. We must seize the opportunities generated by the birth of a new medium to do things we've never been able to do before. Don't look back.

Epilogue:

The Way of Tea

P R I N T media have dominated Western culture for centuries. At the same time, they have shaped the Western taste for exact measurement and repeatability that we now associate not only with print but also with science and mathematics. Print has helped to define our culture and its sense of uniform precision.

Given the emphasis on the visual perception of written words, alphabetic cultures tend to diminish the role of the other senses—sound, touch, and taste. To call on McLuhan one last time—the reason for his position as the patron saint of the digerati should be clear by now—the alphabet caused a sudden <u>breach</u> between auditory and visual experience. So, while alphabetic cultures have come to appreciate precision, sequence, continuity, and logic, nonalphabetic cultures such as the ideographic cultures of China and Japan appreciate an inclusive and rich sensory experience that more highly values intuition. The ideogram is experienced as a whole. In fact, this inclusive aesthetic permeates their culture. For ex-

> Only the phonetic alphabet makes such a sharp division in experience, giving to its user an eye for an ear, and freeing him from the tribal trance of resonating word magic and the web of kinship.
>
> MARSHALL MCLUHAN,
> *Understanding Media*

ample, it is the foundation for the revered Japanese tea ceremony, which itself embodies the essence of Japanese culture.

For nearly one thousand years, the shared experience of brewing and drinking tea has been cherished in Japanese culture. The tea ceremony is entrenched in the Zen aesthetic. It develops the appreciation of each moment as a moment that will occur only once; the sharing of tea between people for one passing moment is an experience to be savored. I am honored to be a guest at a tea ceremony prepared in the Urasenke tradition of the Way of Tea.

I walk down an uneven garden path made from stepping-stones of various shapes and sizes. Connected by the moss that grows between them, the walkway is like a dry river flowing through the garden of raked sand. The ridged white sand is accented here and there with a rough-edged rock. I stop for a minute to admire a bonsai pine along one side. Wind chimes sing almost inaudibly. The walk along the roji is intended to break my connection with the outside world.

Arriving at a small hut, a sukiya, I slide a screen open and enter through a door not more than three feet high. Bending low to pass through the door, I reflect on this act of humility. The interior is devoid of ornamentation, except for an orchid and a single calligraphic image that satisfy the aesthetic of the moment. Parts of the hut are purposely left unfinished so that the play of the imagination can complete it. Fear of repetition is a constant presence. No color or design is repeated. The walls are asymmetrical. This is a room consecrated to imperfection.

Our host enters and sits behind a wooden table. She is radiant—wrapped in the rich silks of her kimono—as she prepares to be humble host to a collection of honored guests. Her "tools" are carefully placed on the table: a ladle, a bamboo spoon, a whisk, a few bowls, and an uneven, angular pitcher. A rounded pot with water sits on glowing coals. To avoid dividing the table into equal halves, nothing is placed in the center.

Our host lifts a black-glazed container filled with a green powder that is the essence of the potent tea and uses the long bamboo utensil

to scoop up just a small amount of the powder, carving a crescent moon. She places the powder in a brown clay bowl that contrasts sharply with the smooth surface of the black container. Every item is to be appreciated for its contribution to the singularity of the moment.

The water boils. Our host picks up a bamboo ladle to add a small amount of boiling water to the brown bowl. She then picks up a whisk to whip the tea into a frothy brew. Every motion is studied, perfected with centuries of tradition.

One cup is ready for serving. Our host places the cup on a lacquer tray and offers it to the first honored guest. He carefully lifts the cup and turns it to the right twice; in a show of deference he drinks from the back of the cup. He sips the tea and acknowledges its excellence.

Our host returns to prepare a second cup of tea. I wait patiently. This second cup is for me.

The Japanese tea ceremony is a celebration of the moment that savors the wholeness of the experience: the images and sounds of the environment; the touch of the teacup and the appreciation of its unique qualities; the taste of the rich green tea. The appreciation of the nonrepetitive, the changing, the dynamic that makes for the uniqueness of the moment. The Way of Tea is the experience of the moment—a state of consciousness that also opens our minds to digital worlds.

The mosaic languages of digital worlds will return us to the discontinuous and diffuse. Even if a basic property of digital technology is perfect repeatability, "repeatable" is exactly what nonlinear hypermedia isn't. Rather than offering a deterministic experience, digital worlds represent the possibility of creating an experience of the moment. Dynamically generated, they are characterized by evolving textures that reveal a new logic. They integrate multiple media—graphics, photos, sound, music, video, animations, virtual worlds, dynamic Java-scripts, interactions, behaviors, evolutions—to build dense sensory environments that are experienced as a whole.

Epilogue

As we move across surfaces, skimming as we jump from one digital domain to the next, the media matrix creates a sense of coherence. As in a mosaic, the structure of the relationships between every part emanates an integrity that is the essence of new digital worlds. The moment resonates. Digital worlds reflect a state of mind unlike any we have known before.

ⁿOTES

INTRODUCTION

14 "guarantee that every document": Adobe Systems advertisements for its Adobe Acrobat On-line Publishing Kit, 1995.

16 "If I knew I'd already be there": This anecdote is from a source which I cannot remember. *Se non è vero, è ben trovato.*

17 "The medium is the message": McLuhan, *Understanding Media,* p. 7.

1. WIRED WORLDS

22 "Hopping from site to site": Although my own writing, this owes its form to a passage quoting a hacker found in Rushkoff's *Cyberia,* p. 16.

23 "The network is the urban site before us": Mitchell, *City of Bits,* p. 24.

24 "The goal isn't so much to build a model": From the author's conversations with David Colleen.

31 "Electric speeds": McLuhan, *Understanding Media,* p. 91.

32 "People in virtual communities": Rheingold, *The Virtual Community,* p. 3.

33 I head over: This discussion group is a composite that draws on the ideas of a few specific people. "Starseed" is inspired by an excerpt from *The Starseed Transmissions,* as quoted in Rushkoff's *Cyberia,* p. 99. Gutenberg draws from Sven Birkerts's *The Gutenberg Elegies,* p. 202. Lestat borrows from Allucquere Rosanne Stone in *The War of Desire and Technology,* chapter 8. Hive-Mind articulates ideas found in Kevin Kelly's *Out of Control,* pp. 25–26. Toronto paraphrases Nelson Thall, director of McLuhan research at the Center for Media Sciences, who expounds on the ideas of Marshall McLuhan in e-mail distributions from Project McLuhan. "McLuhan Post #12," December 1995, is the source of the ideas expressed here.

36 "We lost our innocence": From "The Strange Case of the Electronic Lover," by Lindsy Van Gelder, *Ms.,* October 1985; quoted in Howard Rheingold's *The Virtual Community,* p. 165.

38 A sticking point in the negotiations: Eric Schmitt described the use of virtual simulations in the Dayton peace negotiations: "High-Tech Maps Guided Bosnia Talks," *The New York Times,* November 24, 1995, p. A10.

Notes

2. VIRTUAL WORLDS

42 "Satori City, better known as 'Virtuopolis'": Besher, *RIM*, pp. 53–55.

43 "Audiovisual bodies that people use to communicate": Stephenson, *Snow Crash*, p. x.

43 "They slalom down the monorail track": ibid., pp. 439, 449.

45 "acquire and develop property, assume an online persona": from the introduction to "AlphaWorld" at the Web site of Worlds Inc. (www .worlds.net), February 1996.

45 "a new architecture for an On-line City of Digital Commerce": From internal design documents of IBM Electronic Commerce Services group. The design team included architects Robert Westling (of Steiner Westling) and Bradley Cronk, and Bette Herod, Mark Podlaseck, and Hal Siegel of IBM.

47 "In patently unreal and artificial realities": Benedikt, *Cyberspace*, p. 128.

48 "VR allows you to put your hands around the Milky Way": Negroponte, *Being Digital*, p. 119.

49 "I had this accumulation of geometric ideas": Benoit Mandelbrot, quoted in an interview by Jeffrey Goldsmith, "The Geometric Dreams of Benoit Mandelbrot," *Wired*, August 1994, pp. 92–93.

49 "conceived and developed a new geometry of nature": Mandelbrot, *The Fractal Geometry of Nature*, p. 1.

49 "I could transform my geometric dreams": Benoit Mandelbrot, quoted in an interview by Jeffrey Goldsmith, "The Geometric Dreams of Benoit Mandelbrot," *Wired*, August 1994, pp. 92–93.

53 "Nothing": ibid.

53 "It's impossible to create my fractal constructions in real space": author's conversations with J. Michael James, July 1995.

60 "I take it our friend's still operating under various archaic assumptions": Besher, *RIM*, p. 301.

60 "In truth, America is extremely uncomfortable with nature": Thompson, *The American Replacement of Nature*, pp. 5–7.

3. SOFTWARE WORLDS

68 "What I'm proudest of is my work with computers": This and all subsequent quotations are from the author's conversations with Stephen Wolfram, March 1996.

73 "It was a remarkably simple studio": This and all subsequent quotations are from the author's conversations with Gottfried Michael Koenig, October 1994.

4. ANIMATED WORLDS

80 "When I was little, I played with toy trains": This and all subsequent quotations are from the author's conversations with Craig Reynolds, March 1996.

83 "The goal of the project": This and all subsequent quotations are from the author's conversations with Barry Truax, October 1995 and April 1996.

85 "The idea that computers will help us in the inventing process": This and all subsequent quotations are from the author's conversations with Karl Sims, April 1996.

100 "as ignorable as it is interesting": From Mark Edwards, "Key Changes," in *The Sunday Times* (London), February 11, 1996, p. 15.

100 "For years, I have been using rules to write music": from an interview by Kevin Kelly with Brian Eno, "Eno: Gossip Is Philosophy," *Wired*, May 1995, p. 148.

100 "ever-changing interactive music": Tim Cole, quoted on the Web site of Cole's company Sseyo, the publisher of Koan Music (www.sseyo.com), March 1996.

100 "What I sell is not a recording": from an interview by Garrick Webster with Brian Eno, "Before and After Science," *PC Format*, March 1996, p. 32.

5. GHOSTDANCE

110 "Jadis, si je me souviens bien": from Rimbaud's *A Season in Hell*, trans. Enid Rhodes Peschel, p. 43.

113 "a labyrinth of labyrinths": from "The Garden of Forking Paths," in Borges, *Labyrinths*, pp. 27–28.

6. IN SEARCH OF THE DIGITAL

121 "patron saint": McLuhan holds the honorary position of "Patron Saint" on the masthead of *Wired* magazine.

122 "You see what you see": quoted in Moszynska, *Abstract Art*, p. 202.

122 "What had to be exhibited": quoted in Thierry de Duve, "The Monochrome and the Blank Canvas," p. 250.

123 "A bit has no color, size, or weight": Negroponte, *Being Digital*, p. 14.

7. SCULPTING 0S AND 1S

133 "Every material has its own individual qualities": quoted in Burnam, *Beyond Modern Sculpture*, p. 95.

134 "My drive for self-expression": this and all subsequent quotations are from the author's conversations with J. Michael James, May 1996.

8. DIGITAL LIMITED INC.

150 "A written sign": Derrida, *Limited Inc.*, p. 9.

150 "These possible absences": ibid., p. 50.

151 "Computer displays are low-resolution devices": Tufte, *Envisioning Information*, p. 89.

153 "Your avatar can look any way you want it to": Stephenson, *Snow Crash*, pp. 36–37.

155 "Her eyelashes are half an inch long": ibid.

162 "On the Internet, feature length is 40 seconds": published in a commentary on the GNN Web site (www.gnn.com), March 27, 1995.

164 "lighting up a cig": Stephenson, *Snow Crash*, p. 392.

Notes

9. MOSAICS
168 "During all our centuries": McLuhan, *Understanding Media*, pp. 84–85.
169 "The mosaic is not uniform": ibid., p. 334.
171 "An acid trip, a new cyberpunk novel": Rushkoff, *Cyberia*, p. 3.
172 "Text that branches": quoted in Cotton and Oliver, *Understanding Hypermedia*, p. 24.
172 "There was a queer momentary sensation": Isaac Asimov, *The Naked Sun*, quoted in Heim, *The Metaphysics of Virtual Reality*, p. 31.
174 "Consciousness is regarded": McLuhan, *Understanding Media*, p. 85.
174 "The human mind": quoted in Cotton and Oliver, *Understanding Hypermedia*, pp. 22–23.
175 "A K-line is a wirelike structure": Minsky, *The Society of Mind*, p. 82.
175 "Bill's Naked Lunch Room": Burroughs, *Naked Lunch*, p. xvii.
176 "The Word is divided": ibid., p. 207.
176 "Print gave intensity": McLuhan, *Understanding Media*, p. 315.
177 "I can surf twenty TV channels at once": Rushkoff, *Media Virus*, p. 180.
178 "What I do is I take a page of my writing": quoted in Morgan, *Literary Outlaw*, p. 323.
178 "NAKED Lunch—a frozen moment": Burroughs, *Naked Lunch*, p. ix.

10. DON'T LOOK BACK
182 "glimpse of the future . . . clinging all the more tightly to my books": Birkerts, *The Gutenberg Elegies*, p. 164.
182 "still don't come close": Lyall, "Are These Books, or What?," p. 21.
183 "It is not the literary intelligentsia": Thompson, *The American Replacement of Nature*, p. 70.
183 "every time someone mentions MUDs": Stoll, *Silicon Snake Oil*, p. 8.
183 "You're viewing a world that doesn't exist": ibid., p. 14.
184 "I've rarely met anyone who prefers to read digital books": ibid., p. 11.

EPILOGUE: THE WAY OF TEA
187 "Only the phonetic alphabet": McLuhan, *Understanding Media*, p. 84.

BIBLIOGRAPHY

Benedikt, M. "Cyberspace: Some Proposals." In *Cyberspace: First Steps,* edited by M. Benedikt, pp. 119–224. Cambridge, Mass.: MIT Press, 1992.

Besher, A. *RIM.* New York: HarperCollins, 1994.

Birkerts, S. *The Gutenberg Elegies.* Boston: Faber and Faber, 1994.

Borges, J. L. *Labyrinths.* New York: New Directions Books, 1964.

Burnham, J. *Beyond Modern Sculpture.* New York: George Braziller, 1987.

Burroughs, W. *Naked Lunch.* New York: Grove Weidenfeld, 1990.

Cotton, B., and R. Oliver. *Understanding Hypermedia.* London: Phaidon Press, 1993.

De Duve, T. "The Monochrome and the Blank Canvas." In *Reconstructing Modernism,* Serge Guilbaut, ed. pp. 244–310. Cambridge, Mass.: MIT Press, 1990.

Derrida, J. *Limited Inc.* Evanston, Ill.: Northwestern University Press, 1988.

Dery, M. *Escape Velocity.* New York: Grove Press, 1996.

Fiore, Q., and M. McLuhan. *The Medium Is the Massage.* New York: Touchstone, 1989.

Gates, W. *The Road Ahead.* New York: Viking, 1995.

Gibson, W. *Neuromancer.* New York: Berkley, 1984.

Gleick, J. *Chaos.* New York: Penguin Books, 1987.

Goldsmith, J. "The Geometric Dreams of Benoit Mandelbrot." In *Wired,* vol. 2, no. 8, pp. 92–93.

Hafner, K., and M. Lyon. *Where Wizards Stay Up Late.* New York: Simon & Schuster, 1996.

Heim, M. *The Metaphysics of Virtual Reality.* New York: Oxford University Press, 1993.

Holtzman, S. *Digital Mantras.* Cambridge, Mass.: MIT Press, 1994.

Johnson, G. *Machinery of the Mind.* Redmond, Wash.: Microsoft Books, 1986.

Kelly, K. "Eno: Gossip Is Philosophy." In *Wired,* vol. 3, no. 5, pp. 146–51.

———. *Out of Control.* New York: Addison-Wesley, 1994.

Karl, F. *American Fictions 1940–1980.* New York: Harper & Row, 1985.

La Barre, W. *The Ghost Dance.* New York: Dell, 1978.

Laurel, B. *Computers as Theatre.* New York: Addison-Wesley, 1993.

Levy, S. *Artificial Life.* New York: Vintage Books, 1992.

Lyall, S. "Are These Books, or What? CD-ROM and the Literary Industry." *The New York Times Book Review,* August 14, 1994.

Bibliography

Mandelbrot, B. *The Fractal Geometry of Nature.* New York: W. H. Freeman, 1982, rev. ed. 1983.

McLuhan, M. *Understanding Media.* London: Routledge, 1994.

Minsky, M. *The Society of Mind.* New York: Simon & Schuster, 1986.

Mitchell, W. *City of Bits.* Cambridge, Mass.: MIT Press, 1995.

Morgan, T. *Literary Outlaw.* New York: Avon Books, 1990.

Moszynska, A. *Abstract Art.* London: Thames and Hudson, 1990.

Negroponte, N. *Being Digital.* New York: Alfred A. Knopf, 1995.

Reynolds, C. "Flocks, Herds, and Schools: A Distributed Behavorial Model." In *Computer Graphics,* vol. 21, no. 4 (July 1987).

Rheingold, H. *Virtual Reality.* New York: Summit Books, 1991.

———. *The Virtual Community.* New York: HarperPerennial, 1994.

Rimbaud, A. "A Season in Hell." Enid Rhodes Peschel, trans. Oxford: Oxford University Press, 1973.

Rushkoff, D. *Cyberia.* New York: HarperCollins, 1994.

———. *Media Virus.* New York: Ballantine Books, 1994.

Simpson, F. *Jeff Koons.* San Francisco: SFMOMA, 1992.

Sims, K. "Artificial Evolution for Computer Graphics." In *Computer Graphics,* vol. 25, no. 4 (July 1991).

———. "Evolving 3D Morphology and Behavior by Competition." In *Artificial Life IV Proceedings,* R. Brooks and P. Maes, eds. Cambridge, Mass.: MIT Press, 1994.

———. "Evolving Virtual Creatures." In *Computer Graphics,* Siggraph '94 Proceedings (July 1994).

Stangos, N. *Concepts of Modern Art.* London: Thames and Hudson, 1981.

Stephenson, N. *Snow Crash.* New York: Bantam Books, 1993.

Stoll, C. *Silicon Snake Oil.* New York: Doubleday, 1995.

Stone, A. *The War of Desire and Technology at the Close of the Mechanical Age.* Cambridge, Mass.: MIT Press, 1995.

Strausfeld, L. "Embodying Virtual Space to Enhance the Understanding of Information." Unpublished masters thesis, Massachusetts Institute of Technology, 1995.

Thompson, W. I. *The American Replacement of Nature.* New York: Doubleday, 1991.

Tufte, E. *Envisioning Information.* Cheshire, Conn.: Graphics Press, 1990.

Turkle, S. *Life on the Screen.* New York: Simon & Schuster, 1995.

Wolfram, S. *Cellular Automata and Complexity.* Reading, Mass.: Addison-Wesley, 1994.

PICTURE CREDITS

Virtual San Francisco:
Images prepared by Dennis Doty. Reproduced courtesy of David Colleen, Planet9 Studios. Copyright © 1996 Planet9 Studios, Inc.

HotWired Masthead:
Image courtesy of *HotWired*; copyright © 1996 *HotWired*.

Chat Room Bar Scene:
Image courtesy of The Motion Factory; copyright © 1996 The Motion Factory, Inc.

IBM:
Image courtesy of IBM; copyright © 1996 IBM Corporation. The design team included architects Robert Westling (of Steiner Westling) and Bradley Cronk, and Bette Herod, Mark Podlaseck, and Hal Siegel of IBM.

Mandelbrot Dive:
Images courtesy of the artist; copyright © 1994 Brian Evans.

Fractal Fish:
Images courtesy of the artist; copyright © 1991–1995 J. Michael James.

Perspecta:
Images courtesy of Perspecta; copyright © 1996 Perspecta, Inc.

Michael Jackson and Bubbles:
Jeff Koons: *Michael Jackson and Bubbles*. 1988. Ceramic. 42 x 70 1/2 x 32 1/2 inches. Photo courtesy of the artist; copyright © 1988 Jeff Koons.

Fractal Mountain Sequence:
Images courtesy of the artist; copyright © Alvy Ray Smith.

Cellular Automata:
Images courtesy of the artist; copyright © 1985–96 Stephen Wolfram.

Reynolds' Boids Sequence:
Images courtesy of the artist; copyright © 1986 Craig Reynolds.

Sims Sequence:
Images courtesy of the artist; copyright © 1988–1997 Karl Sims.

GhostDance:
Images courtesy of IBM; copyright © 1995–96 IBM Corporation. "Transformer" music composed by Philip Glass; copyright © 1995 Dunvagen Music Publishers, Inc.

Stella:
Frank Stella: *Tomlinson Court Park*. 1959. © 1997 Frank Stella / Artists Rights Society (ARS), New York.

Warhol:
Andy Warhol: *The Twenty Marilyns*. 1962. Synthetic polymer paint and silkscreen ink on canvas, 76⅜ x 44⅞ in. © 1997 Andy Warhol Foundation for the Visual Arts / Artists Rights Society (ARS), New York.

Munch:
Edvard Munch: *The Scream*. 1893. Photo by Foto Marburg/Art Resource, New York. © 1997 The Munch Museum / The Munch-Ellingsen Group / Artists Rights Society (ARS), New York.

Chameleons, Scarabs, Condor:
Images courtesy of the artist; copyright © 1991–1996 J. Michael James.

Xerox "X":
Image courtesy of Xerox Corporation; trademark of Xerox Corporation.

Myst:
Myst ® is a registered trademark of Cyan, Inc. © Copyright 1993 Cyan, Inc. All rights reserved. Used by permission.

Picture Credits

INDEX

Index

Index

Index

Index